impressionism
an intimate view

SMALL FRENCH PAINTINGS IN THE NATIONAL GALLERY OF ART

Florence E. Coman
Foreword by Philip Conisbee

National Gallery of Art, Washington
in association with D Giles Limited, London

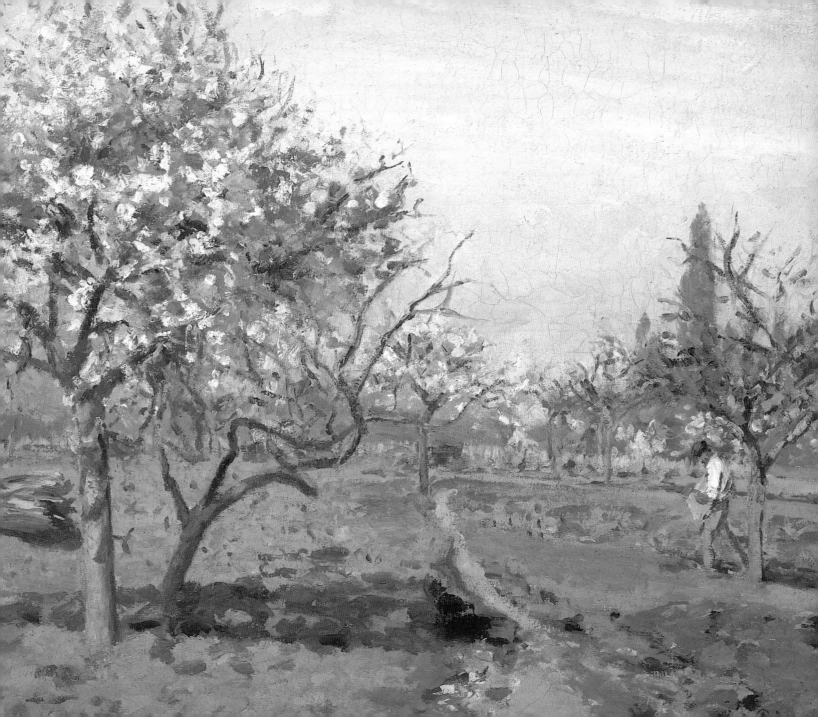

contents

foreword Philip Conisbee

The phrase "small is beautiful" will take on a special resonance for the visitor who lingers in the suite of modestly sized galleries designated *Small French Paintings* in the East Building of the National Gallery of Art. Here is assembled a group of some eighty exquisite paintings, mostly of the nineteenth century, drawn from several collections and individual donations and forming a significant portion of our extensive permanent collection of French art. The exhibited works range from oil studies made by Camille Corot during the early decades of the century, through works by masters of the Barbizon School, and above all by the impressionists, the post-impressionists, and the Nabis, to works by the fauves painted in the opening decade of the twentieth century. A representative selection of these small pictures is celebrated in this little book.

Galleries have been devoted to small French paintings in I. M. Pei's East Building since it opened in 1978. The core collection is that of Ailsa Mellon Bruce, daughter of Andrew W. Mellon, founder of the National Gallery of Art. It was through funds provided by Mrs. Bruce, her brother Paul Mellon, and his wife, that the East Building was created, and although Mrs. Bruce did not live to see the structure rise, the bequest in 1969 of her collection of small French pictures finds a place of honor in these galleries. Most of the Ailsa Mellon Bruce Collection was acquired by her in 1955, when she purchased a collection of about ninety impressionist and post-impressionist pictures, all of them small canvases of exquisite charm and unusual mastery, from the couturier, artist, and collector Edward Molyneux

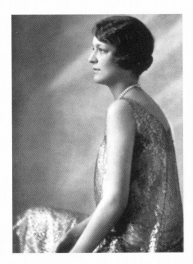

above:
Ailsa Mellon Bruce before
1937. National Gallery of Art,
Gallery Archives

right:
Paul Mellon at the National
Gallery of Art, looking at
small French paintings from
his and his sister Ailsa
Mellon Bruce's collections,
June 1969. National Gallery
of Art, Gallery Archives

(1894–1974), who had been assembling the paintings
in Paris over a period of years.

None of the small French paintings in the Gallery's
collection was originally conceived for a museum set-
ting. Most were done with a view to being sold to pri-
vate collectors, to be displayed in relatively modest
domestic settings; some were not done for sale at all,
but were simply studies painted for the artist's own
pleasure or instruction. It was Paul Mellon who pro-
posed the idea of displaying these works, particularly
those from the collection of his sister, in the specially
designated, more intimate galleries, and in his 1992
memoir *Reflections in a Silver Spoon* he expressed his
satisfaction that "these paintings...given by Ailsa have
been welcomed by the public and have been exhibited
over and over again in small galleries that enhance
their intimacy and their human appeal."

While the Gallery's founding collections, such as
those of Joseph P. Widener (given in 1942) and espe-
cially Chester Dale (whose collection dominated by
French pictures was long on loan to the Gallery, and
bequeathed in 1963) comprise mainly works on a
large and even monumental scale, they also contain
their share of smaller works, which have never been
easy to accommodate in the grand galleries of the
original West Building. Therefore some of these
smaller paintings are displayed in the East Building
along with the Ailsa Mellon Bruce pictures and
include a fine group of small Barbizon landscapes
given by R. Horace Gallatin in 1949 as well as

occasional works from other donors. Over a period of
some thirty years Mr. and Mrs. Paul Mellon have
added a number of small French paintings to com-
plement Mrs. Bruce's 1969 bequest. The intimacy of
these galleries, and the close encounter they encour-
age with the works of art, have proved to be highly
popular with visitors, who would surely endorse Paul
Mellon's feeling that "size has nothing to do with the
quality or importance of a work of art, just as prelimi-
nary drawings or sketches or pastels often have an
immediacy and an emotional appeal far greater than
the final canvas...I am now even more convinced that
small is beautiful."

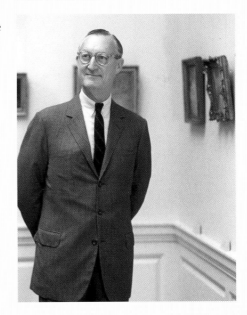

acknowledgments

This book would not have been possible without the guidance and encouragement of Philip Conisbee, senior curator of European paintings and curator of French paintings at the National Gallery. In the French paintings department Kimberly Jones, associate curator, and Michelle Bird, assistant, helped throughout with matters large and small. The project has been shepherded through the editing process by Judy Metro, head of the publishing office, and Karen Sagstetter, senior editor. I am grateful, too, to Sara Sanders-Buell for handling all the necessary photography. It has been a joy to delve into the collections of the Gallery Archives and the Photographic Archives, which yielded fascinating historic photographs, some of which enrich the pages of this book. Maygene Daniels, chief of Gallery Archives, facilitated the project, and Jorgelina Orfila, researcher, and Lauren Melo, archives technician, provided invaluable assistance. I am most grateful to Ruth Philbrick, curator of Photographic Archives, who first drew my attention to the extraordinary photograph of Camille Corot, and to Meg L. Melvin, archivist of modern and contemporary art in the photographic archives, who secured it for this publication.

Florence E. Coman
Assistant Curator of French Paintings

small is beautiful

In our twenty-first-century culture, size is a qualitative yardstick. "Bigger is better" has become axiomatic, while being "small-minded" is a character flaw; "big-hearted" is a virtue and the ability to "get the big picture," prized. The big picture, literally, has long commanded respect and with few exceptions small pictures have been overlooked. The preference accorded to large-scale paintings has a long history, dating back at least to the Renaissance. By the seventeenth century, this predilection was a well-established one that received further affirmation from the newly formed French Academy, which fostered the belief in the superiority of grand-scale history painting over works of modest scale and subject. That ideology would hold sway for the next two centuries.

In nineteenth-century France, monumental history paintings by Jacques-Louis David (1748–1825), Antoine-Jean Gros (1771–1835), Thomas Couture (1815–1879), Jean-Léon Gérôme (1824–1904), and their followers were particularly esteemed for upholding the great academic traditions. Grandiose and edifying, such paintings invariably occupied the most prominent positions at the Paris Salon, where they showcased their creators' technical prowess and compositional inventiveness. The Salon was the officially sponsored art exhibition, run by the Academy under the aegis of a jury composed of its members. Until the 1870s the Salon was the only official exhibition where aspiring artists could show their work and hope for critical and public success. Paintings at the Salons were hung so closely they covered the walls

from chair-rail level up to the rafters, with composi-tions deemed grandest and most successful given pride of place on the lowest level for easier viewing. In a typical Salon, over two thousand pictures would be crowded together in tiers three or four paintings high, so that works placed above the lowest level were difficult or nearly impossible to see. Less important pictures—usually smaller or unconventional works—and those by younger and less established artists were generally relegated to the heights. Berthe Morisot complained about this placement when her painting *The Artist's Sister at a Window* (page 43) was shown in 1870; she wrote her sister Edma Pontillon that it was "hung so high it is impossible to judge it." Within the context of the Salon, scale was not just a matter of preference; it was one of survival. Given the risk of having one's paintings poorly hung—"skied" in common parlance—working on a larger scale was one way to combat that problem. Even hung high, a large canvas would be more visible than a small one.

Despite the stranglehold that the Salon maintained on the official art world, artists could and did produce works on a smaller scale. The rise of a prosperous middle class in the nineteenth century helped to gen-erate a market. Now able to afford luxuries such as art that had once been the exclusive province of the wealthy and titled, the middle class began to acquire smaller works to adorn their more modest resi-dences. Unpretentious subjects—still lifes and genre scenes, in particular—were favorites for the bour-geoisie. But the creation of such small-scale works was

not limited to the commercial market. The academic system, which prized elaborate, grand-scale composi-tions, encouraged artists to produce painted sketches and studies as an integral part of the creative process. They allowed the artist to work up compositions in advance, to play with variations in pose and gesture, and to master the depiction of individual motifs. Such paintings were studio works and as such never exhib-ited during the artist's lifetime, but their very existence bespeaks the particular charm that the small format held for artists. They were even, on rare occasions, given as mementos to friends and admirers as a mark of esteem, further proof of their unique value.

The painted sketch was to play an exceptionally important role in the development of modern land-scape painting. The early nineteenth century wit-nessed a growing interest in naturalism, that is, the

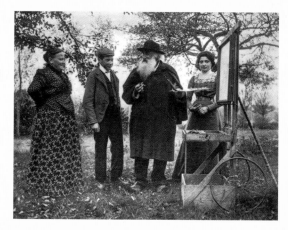

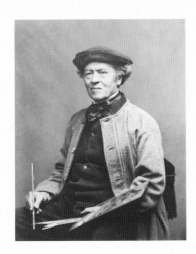

Jean-Baptiste-Camille Corot, c. 1870. Photograph by H. Lavaud. Photographic Archives of the National Gallery of Art

unidealized depiction of nature, and with it an increased emphasis on the practice of painting directly from nature. While this practice was not unprecedented, there had always been practical limits to its viability. The nineteenth century, however, saw the introduction of a number of technical innovations—collapsible easels, portable paint boxes, and most importantly, oil paint in tubes that was mass-produced and commercially sold from the 1830s—that rendered the practice more feasible than ever before, for the professional and the amateur painter alike. In spite of these conveniences, one thing remained unchanged, however: open-air *(plein-air)* painting was firmly tied to smaller formats, whether canvas, cardboard, or wood panel, due to the logistical difficulties of transporting large-scale canvases out of doors.

Among the earliest and most influential practitioners of open-air painting was Jean-Baptiste-Camille Corot (1796–1875). His earliest landscape sketches date from his student days in Italy in the 1820s and, by the 1860s, Corot was established as a leading exponent of landscape painting, often working in a naturalist vein. The practice of open-air painting remained fundamental to his art, and he created a large number of such works throughout his long career. Modest in scale, rapidly executed, and with an emphasis on keen observation of seasonal and atmospheric effects, Corot's open-air studies presage a true revolution in landscape painting.

Corot's experiments in painting outdoors would be continued by the artists of the Barbizon School with whom he was loosely affiliated. This group of artists, so named because they lived and worked mid-century in the Forest of Fontainebleau, in France, in and around the town of Barbizon, shared Corot's belief in the importance of working directly from nature. Its members, Théodore Rousseau, Jean-François Millet, and Narcisse Diaz de la Peña (1808–1876) among them, rejected the refined finish and hackneyed conventions prized at the Salon in favor of a rough, painterly technique and spontaneity of expression.

By the 1850s and 1860s, open-air painting had become a widely established pursuit for aspiring landscape painters, and the artists who would soon become known as the impressionists were frequent practitioners. The methods of Corot and the Barbizon artists profoundly influenced this generation. Claude Monet, Auguste Renoir, and Frédéric Bazille (1841–1870) even went so far as to travel together to paint near Barbizon in 1865, while Camille Pissarro and Berthe Morisot both sought and received the counsel of "Father" Corot, as he was fondly known. They were absorbing lessons from other contemporary artists as well: Eugène Boudin, who instructed Monet in the importance of open-air painting; Gustave Courbet (1819–1877), whose broad and experimental style celebrated the very physicality of the paint surface; and Edouard Manet, who introduced them to the compelling and dispassionate modernity found in scenes of contemporary urban life and the use of broad, fluid brushstrokes as a means to enhance the immediacy of their pictures.

It was the impressionists who were largely responsible for the growing acceptance of small-scale painting in the later nineteenth century. Unlike their predecessors who had kept such works private, hidden away within their studios or in the homes of a few enlightened patrons, the impressionists placed them squarely in the public eye, proudly exhibiting them with the same seriousness of purpose normally associated with works at the Salon but within the context of an exhibition that was uniquely their own.

The relationship between the impressionists and the Salon was largely an unhappy one. During the 1860s, the Salon juries regularly rejected most of the works submitted by avant-garde artists such as Bazille, Manet, Monet, Pissarro, Renoir, Paul Cézanne, and Alfred Sisley. Even Emperor Napoleon III recognized that the jury panel showed excessive severity in 1863, leading to a one-time display known as the Salon des Refusés, which was held concurrently with the Salon in a space adjacent to it. The Salon des Refusés was little more than a palliative that did nothing to redress the growing disenchantment of the younger artists. This was borne out in 1867 when once again the Salon jury rejected the submissions of Bazille, Cézanne, Monet, Pissarro, Renoir, and Sisley. Frustrated by the continuing intractability of the Salon juries, the impressionists decided to mount their own exhibition, one that would be unfettered by moribund traditions and petty politics. At the outset, the impressionists' motives were personal rather than revolutionary. They merely wanted the opportunity to display their art, which was unconventional by the standards of the day. Instead of heroic and moralizing stories from ancient history, the Bible, and mythology, their principal subjects were landscape—usually views of the countryside and suburbs where the artists lived—and the ordinary activities of daily life. Instead of grandiose canvases, they would exhibit works that were more modest in scale but more sincere in their intent and execution.

Theirs was a struggle for recognition. They thought that they would gain acceptance only if their works

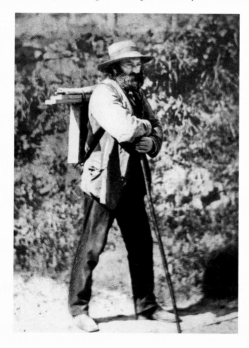

were exhibited fairly, something that was not possible at the Salon. The Salons, selected by artists from the Academy, were dominated by traditional attitudes; juries might grudgingly accept a few works by the young artists but would hang them out of sight. Favorable viewing conditions—good lighting and ample space between paintings—were considered essential by the impressionists. In addition, they wanted to exhibit more than the two works allowed by Salon rules, and they believed that the artists themselves rather than the jury should select works to exhibit. Believing they had no other option, the impressionists left the official system and organized their own exhibition, apart from Manet, that is, who continued to exhibit at the Salon.

When the first impressionist exhibition opened in Paris in April 1874, just one month before the Salon, it heralded a transformation of the arts in the second half of the nineteenth century. The audacious enterprise—the first independent public group show—disrupted entrenched artistic institutions and traditions, liberating artists to explore alternative forms of expression. The show attracted attention and visitors were numerous, but reaction was mixed. Some critics were receptive to their innovations and praised the group for breaking with the Salon system, but reviews by most established writers were harsh and derisive.

Oil sketches were not considered finished art works, yet the impressionists defiantly exhibited theirs. In his review in the satiric journal *Le Charivari*, the critic

Louis Leroy took note of the unmixed pigments and broken brushwork in the impressionists' paintings as characteristics of unfinished sketches—known in French as *impressions*—as well as one Monet painting that bore the title *Impression, Sunrise* (1873, Musée Marmottan Monet, Paris). Ignoring the group's carefully neutral name—"Corporation of Artists: Painters, Sculptors, Printmakers, etc."—he sarcastically dubbed them "impressionists." The relatively loose and open brushwork, immediately recognized as a hallmark of the style, underscored the artists' freedom

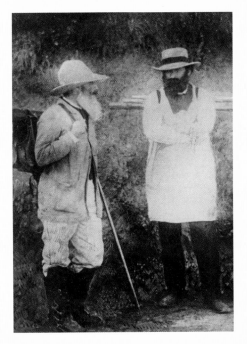

from the meticulously detailed academic manner that previously had been central to French painting.

Despite the generally negative public response to their 1874 exhibition and the financially ruinous outcome of an auction of paintings by Monet, Morisot, Renoir, and Sisley in 1875, the group carried on, holding seven more exhibitions. The eighth and last impressionist exhibition in 1886 was dominated by the work of Georges Seurat and his neoimpressionist technique, a scientifically based system that juxtaposed small touches of unmixed pigments in hues corresponding to the perceived local color, its complement for shadow, the color of light, and reflected color of nearby areas. By the mid-1880s, the leading members of the group were becoming commercially successful, able to show their work with dealers or the newly formed association of independent artists, and their group exhibitions were no longer necessary.

Due in large part to the efforts of the impressionists, the perception of what qualified as a "finished" work of art was forever transformed. Smaller, sketchier paintings, so long undervalued by the public at large, were increasingly admired for their freshness and immediacy of expression. Future generations of artists would embrace this newfound acceptance and would build upon it in ways that suited their own artistic vision.

This was certainly true of the artists known as the post-impressionists. The successor to impressionism, post-impressionism does not define a style or movement. Rather, it was coined by the English artist and critic Roger Fry in 1910 to designate the variety of styles that had evolved out of impressionism toward the middle of the 1880s. It is usually associated with four principal artists: Cézanne, Seurat, Paul Gauguin (1848–1903), and Vincent van Gogh. Work by the post-impressionist masters is highly distinctive: Cézanne's rigorous compositions composed of planes and geometric forms; Seurat's methodical application of dots; Gauguin's lush color harmonies; Van Gogh's forceful brushwork. Idiosyncratic though each artist's work was, one salient characteristic of post-impressionism as a whole can be discerned: the post-impressionists were interested in far more than the fleeting visual effects that had preoccupied the impressionists. They were also artists for whom the creation of art was a deeply personal affair. Although all produced large-scale paintings designed to make grand statements, many of their finest works are smaller scale and speak directly and intimately to the viewer.

This notion of intimacy of expression was an important one at the end of the nineteenth century. Symbolism, with its emphasis on the world beyond the physical, is one of its manifestations. The strange and mysterious paintings of Odilon Redon reflect such concerns. With their jewel-like colors and elaborate surfaces, they are like objects of veneration, intended for contemplation. Another of these was the group of artists known as the Nabis (from the Hebrew for "prophets"). Inspired by Gauguin, the Nabis insisted on the primacy of the physical existence of a painting

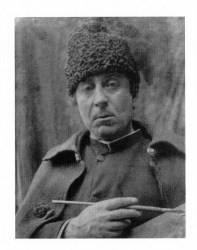

Paul Gauguin with brush and palette, 1888. National Gallery of Art, John Rewald Papers

—paints arranged on a flat surface—over the convention recognizing it as a re-creation of nature. In particular Pierre Bonnard and Edouard Vuillard were known as "intimists" and much admired for the quiet intimacy of their small-scale paintings.

Around the turn of the century a new group of young artists took inspiration from the work of Seurat as well as that of Cézanne and Van Gogh. The paintings they showed at the Salon d'Automne exhibition in Paris in 1905—works with harsh, gaudy colors and exaggeratedly crude brushwork—earned them the derisively applied label *fauves*, in English, "wild beasts." Henri Matisse was the unofficial leader of the loose-knit bunch, in company with Georges Braque (1882–1963), André Derain (1880–1954), Raoul Dufy, Albert Marquet (1875–1947), and Maurice de Vlaminck (1876–1958). As with the impressionists in 1874, the reception of the fauves in 1905 was wildly negative. And as with the impressionists, the paintings that so disconcerted people were luminous works of moderate size and mundane subject matter. Although small-scale works were by then widely accepted, artists still found ways to render them challenging to contemporary audiences.

For today's public, far removed from the artistic battles waged a century ago, these small-scale paintings may have lost something of their dangerous edge, but their visual impact endures. In many respects such paintings can be appreciated more fully today than ever before. Small paintings have virtues that grander, more awe-inspiring paintings cannot match. They are more readily experimental, the perfect means for an artist to try different styles, techniques, and equipment and see results quickly, results that sometimes produce unexpected or accidental effects. Small paintings can showcase virtuoso brushwork that might be less prominent in a monumental painting. The smaller size also gives individual viewers a more intimate experience, inviting a closer, more personal and discrete interaction with the work of art, eroding the barriers between artist and painting and between painting and individual viewer. Such little pictures invite one-on-one contemplation, offering a private encounter that we invite you to experience, even in the public spaces of the *Small French Paintings* exhibition.

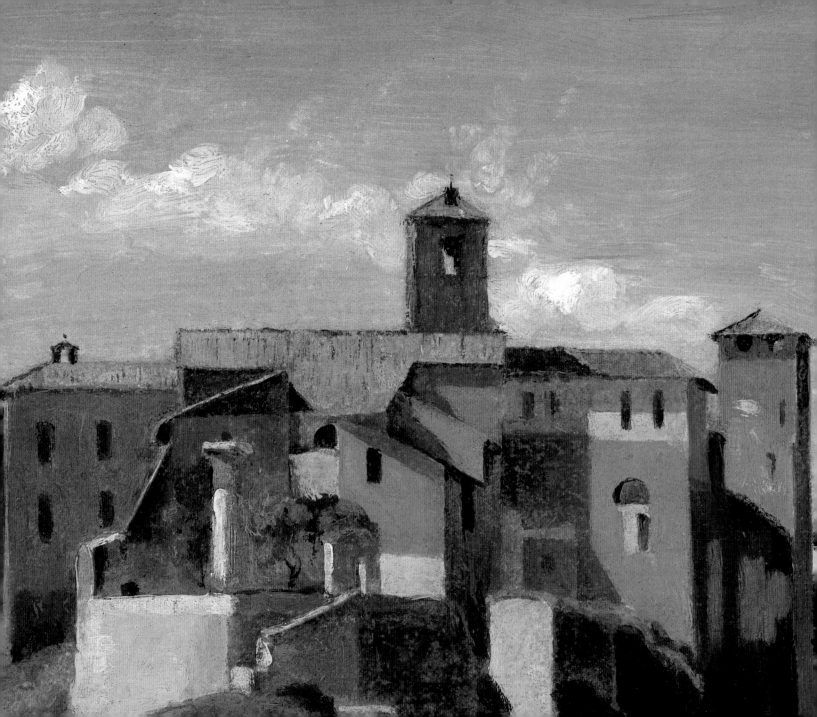

OPEN-AIR PAINTINGS

Painting out of doors was an experience intrinsic to the development of landscape painting in the nineteenth century. Initially, such painting was limited to studies painted before nature in order to train the artist's hand in responding with brushes and paints to what he saw around him. Over the course of the century, however, it began to take on a more prominent role. Among the most influential of its early advocates was Corot, who began the practice in the early 1820s and honed his abilities during his sojourn in Italy. Corot never entirely abandoned the practice of painting open-air sketches and, to the modern viewer, these smaller outdoor studies now stand as finished works in their own right. However he did not exhibit them, and they remained unknown to the public at large during his lifetime. These open-air studies had an effect on Corot's larger studio landscapes, infusing them with an intimate feeling for nature.

This approach was shared by artists of the Barbizon School, the generation of landscape painters that rose to prominence in the 1830s and 1840s and who, like Corot himself, worked largely in and around the Forest of Fontainebleau. These artists strove to create works that retained the immediacy of experience and spontaneity of expression essential to open-air painting.

This practice would continue with the impressionists who were all great admirers of Corot and his methods. It was these artists who gradually took open-air painting to the next level, executing works completely on site (rather than in the studio) that were then proudly exhibited as finished works. Open-air painting ceased to be a means to an end and became the end in itself.

Jean-Baptiste-Camille Corot, French, 1796–1875,
The Island and Bridge of San Bartolomeo, Rome, 1825/1828
(detail)

Corot began his career with lessons from landscape specialists Achille-Etna Michallon (1796–1822) and Jean-Victor Bertin (1767–1842), then traveled to Rome in 1825 to complete his studies. *The Island and Bridge of San Bartolomeo, Rome* is an oil sketch that Corot painted there sometime before his return to Paris in 1828. In accord with his training, Corot situated himself on the bank of the Tiber where a bend provided a vantage for a head-on view of the island of San Bartolomeo. As was his practice, he executed the work in a single sitting on prepared paper of a size that his paint box could safely accommodate. Once he had established the broad outlines of the sketch in three horizontal zones of sky, buildings and bridges, and water, Corot noted the appearances of the layered facades as he brought a geometric regularity to the crowded architecture. Suffused with sunlight, the limpid scene is lucid and compelling.

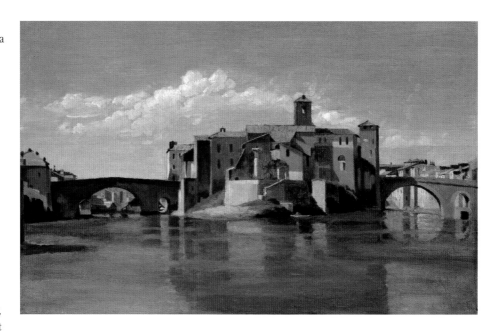

above:
Jean-Baptiste-Camille Corot
French, 1796–1875
The Island and Bridge of San Bartolomeo, Rome, 1825/1828
oil on paper on canvas, 27 x 43.2 (10⅝ x 17)
Patrons' Permanent Fund

right:
Rocks in the Forest of Fontainebleau, 1860/1865
oil on canvas, 45.9 x 58.5 (18 x 23)
Chester Dale Collection

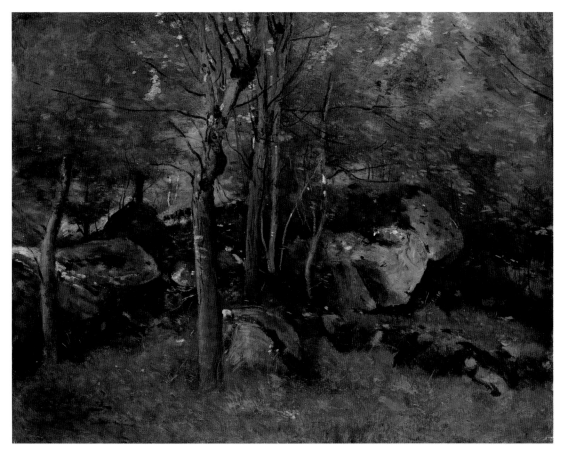

Grains of sand embedded in the paint are proof that Corot painted this forest interior in the open. Here, patches of sunlight spilling through openings in the leafy cover to enliven the dark grotto were transcribed as thick flecks of orange-white. Corot regularly painted in the Forest of Fontainebleau beginning in the 1820s, but in his later landscapes he avoided the famous sites recommended in guidebooks, which appear frequently in works by the Barbizon artists and other contemporaries. Thus neither the specific site nor the precise date of the work can be determined with certainty. *Rocks in the Forest of Fontainebleau* is particularly appealing to modern eyes for the unstudied naturalism of the open-air sketch, which Corot, the genial master, recommended to artists who came for advice. Corot considered such outdoor studies private and would exhibit only the idealized landscapes he had composed in his studio.

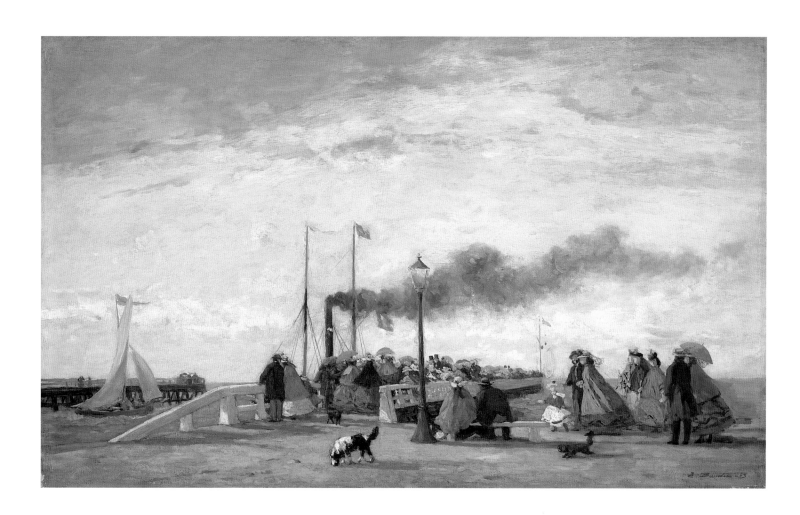

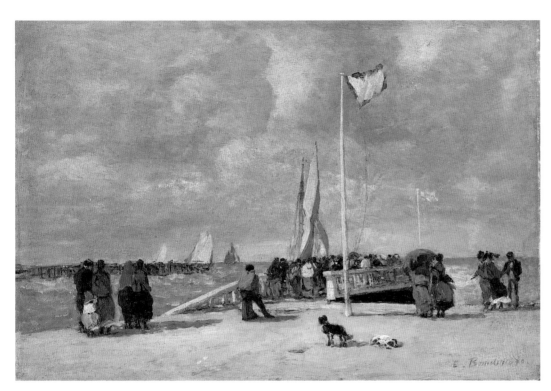

Eugène Boudin, who specialized in landscapes depicting coastal Normandy and Brittany, was encouraged to paint the well-to-do tourists who began to patronize the region thanks to the development of train services from Paris in the early 1860s. In *Jetty and Wharf at Trouville*, a stylish throng crowds a pier, waiting for the steam ferry, while in the channel beyond, a pleasure boat sails briskly to open water.

On the Jetty, probably also painted in Trouville, likely depicts a different jetty with a less affluent group crowding toward a boat whose sails are billowing in the wind. Minor differences in content aside, *Jetty and Wharf* is finely wrought while *On the Jetty* may seem somewhat crude by comparison. Boudin painted the latter in the open and was therefore subject to erratic weather conditions—wind-whipped sand could be a problem. He may have had a general compositional scheme in mind when he began, but the haste and spontaneity of his working outdoors is evident in pentimenti (places repainted when the artist changed his mind) such as the phantom flagpole at right, and the male figure at far right, only partly sketched in atop the water.

left:
Eugène Boudin
French, 1824–1898
Jetty and Wharf at Trouville, 1863
oil on wood, 34.6 x 57.8
(13⅝ x 22¼)
Collection of Mr. and Mrs. Paul Mellon

above:
On the Jetty,
c. 1869/1870
oil on wood, 18.4 x 27.4
(7¼ x 10¾)
Ailsa Mellon Bruce Collection

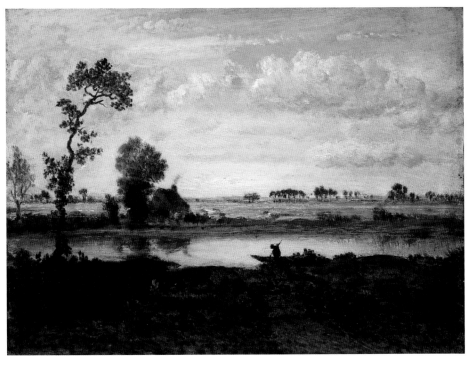

His success at the 1855 World's Fair in Paris enabled Daubigny to purchase and outfit Le Botin, a barge that became his floating studio, and thereafter he preferred to work on the Seine and especially the Oise. He and his boat became a familiar sight for Claude Monet in Argenteuil and Camille Pissarro in Pontoise. The Oise fills the foreground of *Washerwomen at the Oise River near Valmondois*, suggesting that the view was painted on the spot from the Botin. Daubigny found the subject congenial, and he depicted the locale in more than a dozen paintings.

Rousseau's similarly fresh-looking *Landscape with Boatman* was probably not painted from life. Such scenery was so familiar to the artist that he could paint stock elements like the silhouetted boatman and cottage with smoking chimney from memory, to compose small, quickly executed studio compositions for the art market.

left:
Charles-François
Daubigny
French, 1817–1878
*Washerwomen at the Oise
River near Valmondois,*
1865
oil on wood, 24 x 46
(9½ x 18⅛)
Gift of R. Horace Gallatin

above:
Théodore Rousseau
French, 1812–1867
Landscape with Boatman,
c. 1860
oil on wood, 19.4 x 26.3
(7⅝ x 10⅛)
Gift of R. Horace Gallatin

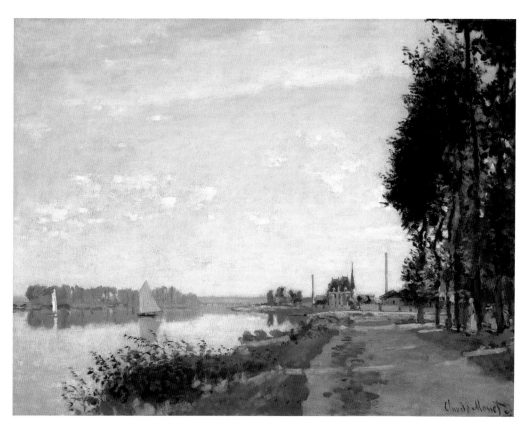

Claude Monet
French, 1840–1926
Argenteuil, c. 1872
oil on canvas, 50.4 x 65.2
(19⅞ x 25⅝)
Ailsa Mellon Bruce Collection

After the Franco-Prussian War in 1870, Monet followed Edouard Manet's advice and found a house to rent in Argenteuil, a suburb located on a main rail line from Paris, and settled there with his wife and young son in late 1871. Argenteuil displays the provincial charm and quiet that drew people, especially the wealthy bourgeoisie, to the community. Afternoon light spills past a single group of women lingering under the trees of the Promenade, a park along the river; just two sailboats ply the mirror-still water; and factory buildings in the distance are idle. Sailing, in vogue at the time, was a principal attraction; the Seine at Argenteuil was particularly well suited for the sport.

Although this was painted in the open, it is unlikely that Monet observed the idyllic scene that he depicted. On weekdays, Argenteuil's noisy factories typically belched smoke and polluted the air with a powerful stench and a parade of barges moved up- and downstream to carry goods to and from Paris. On weekends the river and town were crowded with sportsmen and sightseers daytripping from the city. But freshly observed light effects and deft, nuanced transcription of the clouds mark *Argenteuil* as based on working in the open.

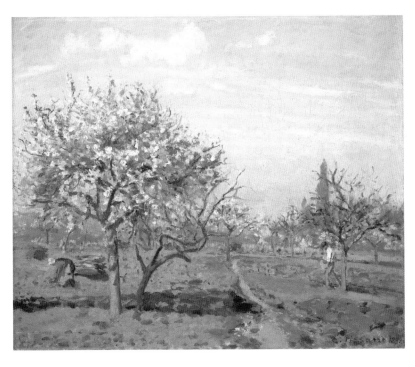

Camille Pissarro
French, 1830–1903
Orchard in Bloom, Louveciennes,
1872
oil on canvas,
45.1 x 54.9 (17¼ x 21⅝)
Ailsa Mellon Bruce Collection

Early in his career Pissarro described himself as a pupil of Corot, a connection recalled in this 1872 painting by the artist's broad method of composing. Unlike Corot, Pissarro seldom painted preliminary studies even for exhibition pieces such as *Orchard in Bloom, Louveciennes.* Pencil studies for some landscapes of this period survive although none is known for *Orchard in Bloom,* but he would also paint without such preliminaries, laying in the broad outlines of his composition in pencil or thinned oils and gradually working it up, in one or more sessions in the open air. Pissarro painted *Orchard in Bloom* in the spring of 1872, shortly after his return from London, where he sheltered his family during the Franco-Prussian War.

The painting was sold soon after to a new and important patron, the art dealer Paul Durand-Ruel. *Orchard in Bloom* was one of the earliest impressionist purchases by Durand-Ruel, who is now remembered for his courageous and sustained support of the impressionists. In 1874 Pissarro borrowed the painting from Durand-Ruel to show in the first impressionist group exhibition. Pissarro apparently regarded *Orchard in Bloom* well, listing it first among the five paintings catalogued on that occasion and repeating the motif in later paintings.

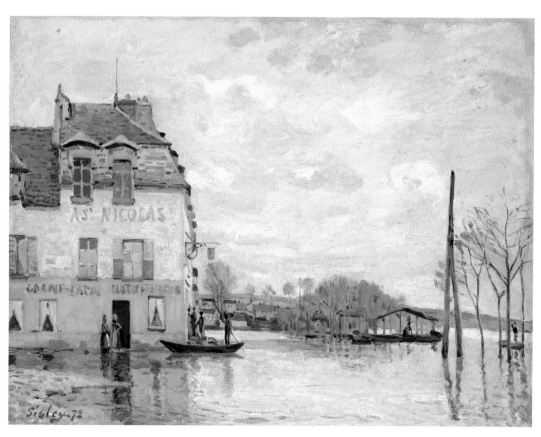

Alfred Sisley
French, 1839–1899
Flood at Port-Marly, 1872
oil on canvas, 46.4 x 61
(18¼ x 24)
Collection of Mr. and Mrs.
Paul Mellon

Flooding early in 1872 drew Sisley to Port-Marly, a suburb of Paris. Rather than the dramatic or picturesque, purely visual effects produced by rain-laden clouds and water-covered streets engaged his attention. He took his equipment to the site and created a half dozen canvases. The composition is traditional, the restaurant building at left and pylon at right framing a view of the floodwaters and hillside beyond. *Flood at Port-Marly* was painted quickly on the scene, probably in a single session, in muted tones of a wide spectrum of hues. The artist applied a thin layer of fluid and calligraphic brushstrokes, which he varied in response to momentary effects of light in the clouds and across the water.

Another flood in Port-Marly took the artist back again in 1876, and he echoed this 1872 composition in two similar pictures, suggesting that he found this motif pleasing and the painting successful.

Stanislas Lépine
French, 1835–1892
*View on the Outskirts of
Caen*, 1872/1875
oil on wood, 17.6 x 28.1
(6¹⁵/₁₆ x 11¹/₁₆)
Collection of Mr. and
Mrs. Paul Mellon

Like Pissarro, Lépine worked with Corot at the start of his career, and he, too, designated himself a pupil of the master in the catalogue of the 1866 Salon. This small oil sketch bears the imprint of Corot's method of working in the open. Lépine painted *View on the Outskirts of Caen* from a vantage overlooking the rooftops and upper floors of a cluster of dwellings in a prosperous neighborhood of his native Caen. Sunlight from his left illuminates the foreground, while storm clouds approaching from the right threaten a passing downpour. The swiftly changing weather must have hastened Lépine, yet his painting looks unhurried and scrupulously observed.

Lépine participated in the first impressionist exhibition in 1874 but the artist is still little known and his work is typically dismissed in favor of that of more famous colleagues.

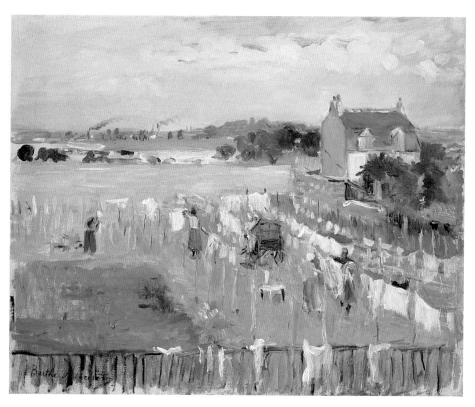

Berthe Morisot
French, 1841–1895
*Hanging the Laundry Out
to Dry*, 1875
oil on canvas, 33 x 40.6
(13 x 16)
Collection of Mr. and
Mrs. Paul Mellon

Morisot married Eugène Manet, brother of painter Edouard Manet, in late 1874. Berthe Morisot's husband supported her professional aspirations and even encouraged her participation in the impressionist exhibitions. Morisot painted *Hanging the Laundry Out to Dry* in spring 1875, when the couple occupied a Manet family property in Gennevilliers, a town across the Seine from Argenteuil. This sprightly study shows a commercial laundry, an industry then in development. Morisot organized her composition along orthogonals created by the laundry lines. The artist eschewed the appearance of careful finish—she left the canvas readily visible in the area of the casually brushed fence that runs across the bottom of the picture—underscoring the spontaneity of the painting and speed of its execution, qualities that contemporary critics failed to appreciate.

Morisot showed *Hanging the Laundry Out to Dry* at the 1876 impressionist exhibition. One critic commented, "Given her delicate color and the adroitly daring play of her brush with light, it is a real pity to see this artist give up her work when it is only barely sketched because she is so easily satisfied with it." (Alfred de Lostalot (A. de L.), *La Chronique des Arts et de la Curiosité*, 1 April 1876).

The sensational legends that have surrounded Van Gogh can obscure the logic and intelligence that characterize his work. The artist's correspondence, particularly after he moved south to Arles, contradicts popular lore and attests to the deliberation, sensitivity, and integrity of his art. During just two weeks in June 1888, Van Gogh completed a group of ten paintings of the harvest, among them *Farmhouse in Provence*. He prepared carefully for the campaign, then executed all ten in the outdoors in a furious and inspired burst of creative energy. In a letter to his brother Theo, Vincent wrote briefly that he could at last understand the difficulties faced by artists like Cézanne, working in the open during the chancy mistral season. The massed areas of color in this painting, particularly the "high yellow note" of which he was so proud that season and that was the general subject of the ten pictures, are characteristic of much of Van Gogh's work from 1888 to 1890. They allude to a deistic belief in the cyclical rhythms of nature.

Vincent van Gogh
Dutch, 1853–1890
Farmhouse in Provence, 1888
oil on canvas, 46.1 x 60.9
(18⅛ x 24)
Ailsa Mellon Bruce
Collection

SKETCHES AND STUDIES

Sketches *(esquisses)* and preparatory studies *(ébauches)* are among the most common types of small-format paintings produced in the nineteenth century. It was a well-established academic practice for artists to develop compositions and individual motifs on a small scale prior to undertaking works of more ambitious dimensions, especially those destined for the highly competitive arena of the Salon. Indeed, student artists were instructed in this method at the state-sponsored Ecole des Beaux-Arts, since it gave them latitude to tinker with the components of their compositions and balance the play of darks and lights. This strategy was both methodical and practical.

The relationship between sketch and definitive work is not always straightforward, however. In addition to serving as compositional tools, sketches provided the artist with a means to familiarize himself or herself with a model or motif. As such, sketches reflect a complex and often fluid dialogue between artist and subject. Such works could serve as a kind of visual fodder for the artist who could draw upon them repeatedly for other works, sometimes over the course of many years. And in some, albeit more rare cases, the sketch followed the definitive work, allowing the artist an opportunity to revisit a composition or a motif.

The paintings included in this section are related to other paintings and projects, some realized and others not. Through painted studies, the artist could record visual experience—pose, gesture, lighting—in its most immediate terms, with a freedom and directness absent from large-scale works.

Edouard Manet, French, 1832–1883,
At the Races, c. 1875 (detail)

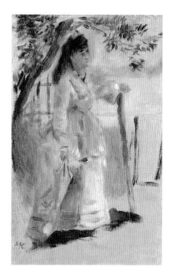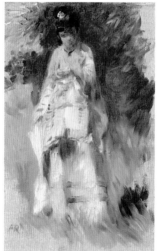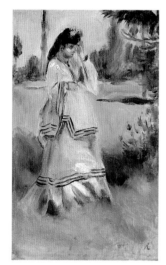

Auguste Renoir

Woman by a Fence, Woman Standing by a Tree, and *Woman in a Park* are part of a group of some thirty sketches depicting Lise Tréhot, Renoir's model and mistress in the 1860s. These sketches, summarily painted, show Lise in similar costume—identical in two of these three—and setting, a cultivated parkland, perhaps the Bois de Boulogne. Her precise pose and specific situation vary from work to work, as if the artist were studying different possibilities for the eventual large composition. While the dress and pose suggest that they may be related to *Lise* (Museum Folkwang, Essen), a full-length portrait that Renoir exhibited in 1868, echoes of these poses can be found in several major works by Renoir from as early as 1866 and as late as 1870. Given the prohibitive costs of hiring professional models, especially for a struggling young artist like Renoir, it is not at all surprising that he may have turned to these sketches several times, drawing upon them whenever necessary.

Technical examination indicates that the oil sketches may have been vignettes painted on one canvas that Renoir later cut into individual images—the palette and paint handling are similar in all and an unpainted reserve was left around each. The top edge of *Woman Standing by a Tree* seems to be the top edge of the original (pre-cut) canvas.

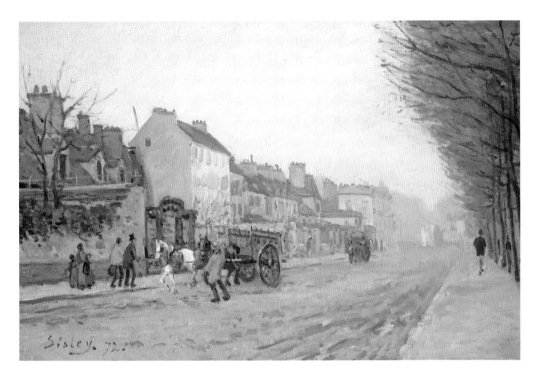

Alfred Sisley

Sisley painted this image of Boulevard Héloïse during a visit to Argenteuil, the suburban village where Monet resided. The picture is a simple, directly observed composition in a palette of hues muted to match the overcast skies and earthen tones of buildings and leafless trees. Looking along the angle of the sidewalk in the direction of the train station and town center, Sisley turned his back on the factories toward which the wagons labor. Sidewalks on both sides of the street are a sign of the modernity and urbanity of the community. The trees at the right cut off a view of the Seine and form the boundary between the busy street and the Promenade, a park shown in Monet's 1872 picture *Argenteuil* (page 22).

Monet painted a nearly identical view of the same stretch of the fog-bound thoroughfare (Yale University Art Gallery, New Haven), indicating that the two friends probably worked together. The two must have been in close proximity, with Monet's easel planted on the road and Sisley's on the sidewalk (see Paul Hayes Tucker, *The Impressionists at Argenteuil*, exh. cat., National Gallery of Art, Washington, and Wadsworth Atheneum Museum of Art, Hartford, 2000, 50–53). Sisley was more attentive to rustic aspects of the scene, giving prominence to a horse-drawn cart, ruts in the road surface, and the irregularity of the buildings lining the road, while Monet emphasized the broad, smooth sweep of the boulevard.

Alfred Sisley
French, 1839–1899
Boulevard Héloïse, Argenteuil, 1872
oil on canvas, 39.5 x 59.6 (15¹/₂ x 23¹/₂)
Ailsa Mellon Bruce Collection

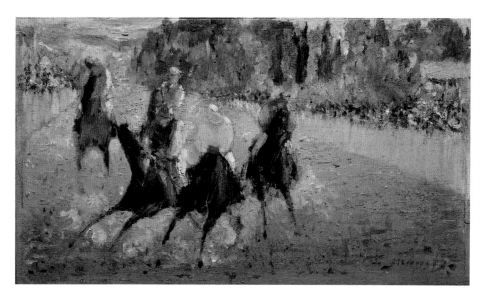

Edouard Manet
French, 1832–1883
At the Races, c. 1875
oil on wood, 12.6 x 21.9
(5 x 8⁹⁄₁₆)
Widener Collection

The bright colors and broken brush-
work of *At the Races* indicate that the
vivid image of jockeys and horses rush-
ing down the center of the racetrack in
the Bois de Boulogne was painted in
about 1875. This tiny work painted on a
wood panel has the fresh appearance of
an open-air sketch but more likely was
executed in Manet's studio. The com-
position is related to a group of works
Manet created in the preceding decade:
a monumental racing painting that he
dismembered of which two fragments
survive, a preliminary study for the
entire composition in gouache, a repe-
tition in oils, and a lithograph that was
Manet's starting point for the National
Gallery's *At the Races*. In this painting,
Manet returned to the original compo-
sition, but moved the horses and riders
to the immediate foreground, com-
pressing spectators, fence, and grand-
stand at the margins to emphasize the
headlong speed and grace of the ath-
letes. It is a vibrant reimagining of the
subject that displays a spontaneity
more associated with a preparatory
work than a later variation.

Simon Hayem is a preparatory study for a large-scale portrait exhibited in the Salon of 1875 (Musée Municipal, Hazebrouck). Hayem, a wealthy banker from Paris, commissioned this painting after seeing the portrait of Bastien-Lepage's grand-father that the artist had exhibited the previous year at the Salon. The sketch is quite similar to the finished portrait apart from the position of the hands, which are interlaced in the final version, and the brushwork, which is applied less rapidly and broadly. For his portrait, Bastien-Lepage adopted a somber palette dominated by black, gray, and brown that is not only suited to the sitter's profes-sion but also heightens its visual effect by establishing a sharp contrast between the sitter's face, hands, and shirt and the dark ground and his waistcoat. Both in its palette and style, it intentionally recalls portraits by realist painters such as Gustave Courbet and particularly Edouard Manet whom Bastien-Lepage greatly respected. His realistic approach is equally apparent in his depiction of the sitter's coarse features and physical bulk, which the artist accentuates rather than conceals. The result is an imposing but nevertheless sympathetic portrait of a Parisian bourgeois.

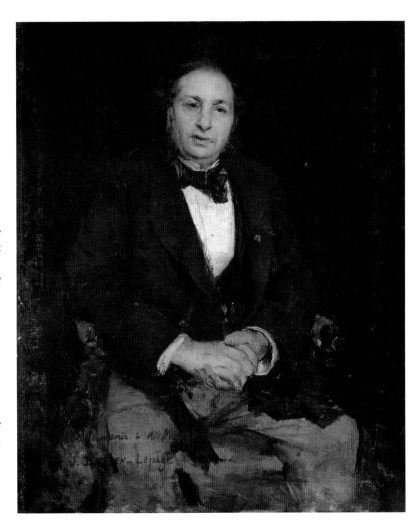

Jules Bastien-Lepage
French, 1848–1884
Simon Hayem, 1875
oil on canvas, 40.5 x 32.6
(15⅞ x 12⅞)
Chester Dale Collection

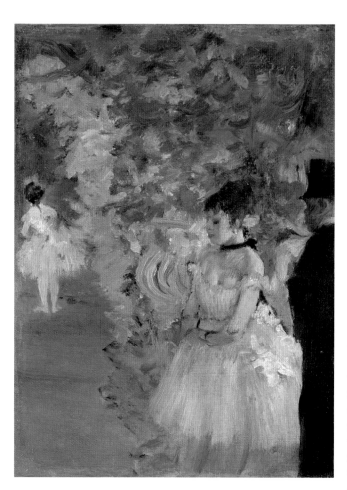

Ballet performers were Degas' principal subject. Almost every conceivable aspect of dancers' lives, on and off-stage, appears in hundreds of paintings, pastels, drawings, prints, and sculptures spanning the artist's career. Degas' detached and ironic attitude is plainly evident in his presentation of the subject here—an older, formally clad gentleman patron is ogling a young dancer in the wings.

In the early 1870s a friend of the artist, author Ludovic Halévy, wrote a series of satiric stories about two young dancers, Pauline and Virginie Cardinal, and their family, published in 1883 as *La Famille Cardinal*. In about 1876 Degas began to make monotype prints based on the stories, a series that included over thirty prints by 1883. On the basis of style, *Dancers Backstage* appears to date from the same period (i.e., 1876 to 1883), and it is closely related to the monotypes in scale and subject. But as is often the case in the work of Degas, the precise relationship remains unclear. Degas often reused compositions and introduced figures from earlier works as part of his creative process. As a result, everything Degas produced became a fecund source of inspiration for new works of art.

Edgar Degas
French, 1834–1917
Dancers Backstage,
1876/1883
oil on canvas, 24.2 x 18.8
(9½ x 7⅜)
Ailsa Mellon Bruce
Collection

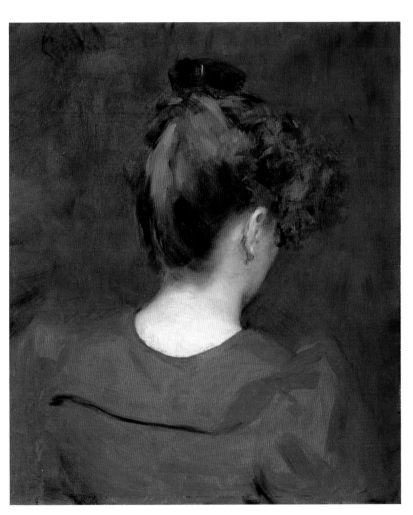

Carolus-Duran, a contemporary of the impressionists, was a more traditional artist who specialized in portraiture. His *Study of Lilia* is a tour de force of suave paint handling, setting pale skin against chestnut hair, red-orange dress, and rich red background. The bust-length oil sketch from above and behind the woman called Lilia has the casual brilliance of spontaneous invention. *Study of Lilia* is related to a seated nude, *Lilia* (Préfecture de l'Ardèche, on deposit from the Musée d'Orsay, Paris) that garnered significant critical praise when shown in Paris in the first exhibition of the Société Nationale des Beaux-Arts in 1890. Strictly speaking it is not a study for the larger painting, but rather a variation on a theme—Lilia's nape—here discreetly and even coyly displayed above the modest collar of her blouse. While it was almost certainly painted at the same time as the nude, the study is undeniably the more intimate work and remained in the artist's possession until his death.

Carolus-Duran
(Charles-Emile Auguste Durand)
French, 1837–1917
Study of Lilia, 1887
oil on canvas, 55 x 46
(21⅛ x 18⅛)
New Century Fund, Gift of Edwin L. Cox–Ed Cox Foundation

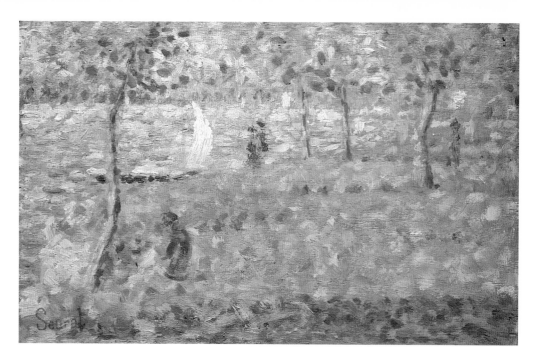

Georges Seurat

As the title indicates, *Study for "La Grande Jatte"* is a study for *Sunday Afternoon on the Island of La Grande Jatte* (Art Institute of Chicago). The monumental finished painting was to be a showcase on a grand scale of Seurat's new neoimpressionist technique. The traditionally trained artist prepared by making preliminary drawings and paintings, around seventy in all. Some concentrate on the individual figures and trees; some address the overall arrangement of the setting or disposition of the figures; some focus on the whole.

Study for "La Grande Jatte" is one of the little oils painted on a wood support sometimes described as a cigar box lid. In them, the artist repeatedly studied the configuration of the landscape, the rhythmic pattern of sun and shadow, the selection and placement of the figures, the shoreline and river. Here he used abbreviated dashes of paint applied with deliberate haste, reworking and refining the composition yet leaving wood visible in spaces between the brushmarks. Seurat's was a gradual, painstaking process, almost anti-impressionist in his

lack of spontaneity. Yet he could preserve the fresh atmosphere in studies—of working-class relaxation just outside Paris in the case of this painting—and recreate it on a grand scale in the finished composition. The success of *Sunday Afternoon on the Island of La Grande Jatte* propelled Seurat to the forefront of the avant-garde when he exhibited it at the eighth and last impressionist exhibition in 1886.

Georges Seurat
French, 1859–1891
Study for "La Grande Jatte," 1884/1885
oil on wood, 15.9 x 25 (6¼ x 9⅞)
Ailsa Mellon Bruce Collection

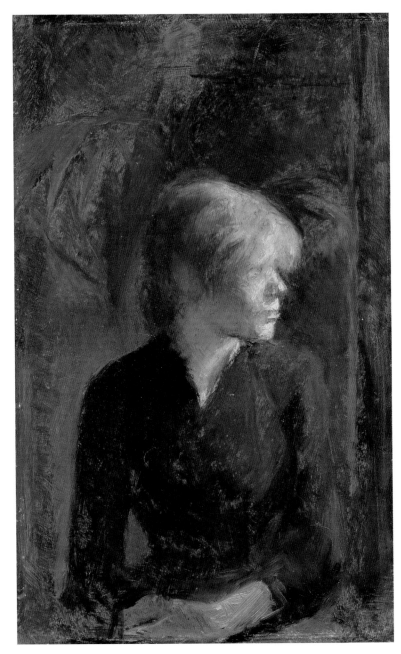

Carmen Gaudin is a small sketch of a woman Lautrec claimed to have encountered by chance. He exclaimed to a friend, "She's a stunner! What a mean look! It would be so marvelous to get her as a model." (Francois Gauzi, *Lautrec et son temps*, Paris, 1954, 129). In 1885 Gaudin sat for Lautrec, who in one session painted several small oils, among them this one. Between 1885 and 1889, Lautrec based several important works on the Carmen studies, including two that seem directly related to the National Gallery painting: *The Laundress* (private collection) and *A Montrouge—Rosa la Rouge* (The Barnes Foundation, Merion, Pennsylvania).

The relationship of sketch to finished composition is further complicated by two photographs of Gaudin that apparently were made subsequently, at Lautrec's direction. In them, Carmen is posed in a doorway, much as Lautrec described their first meeting. Her hair and costume are as they appear in the oil sketches. In one she is shown full length, looking to the left; the lighting changed for the second snapshot, a half-length Carmen looking to the right. This use of both oil sketch and photography was Lautrec's practice at this time and was unique to the artist.

Henri de Toulouse-Lautrec
French, 1864–1901
Carmen Gaudin, 1885
oil on wood, 23.8 x 14.9
(9⅛ x 5⅞)
Ailsa Mellon Bruce
Collection

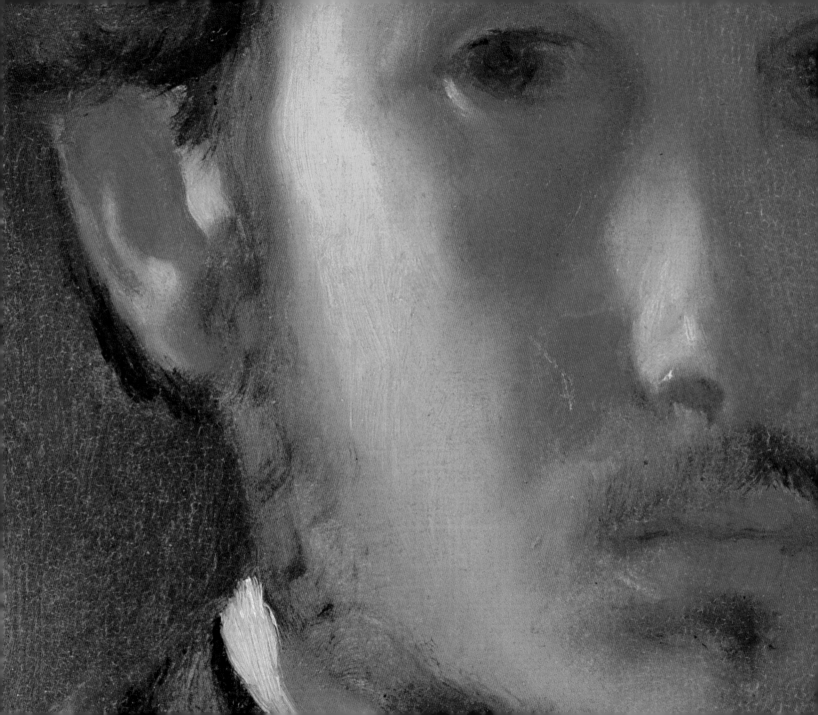

INTIMATE PAINTINGS

One salient quality of smaller-scale paintings is their intimacy. Certain subjects, those drawn from an artist's personal experience—self-portraits or portraits of family and friends, for example—are inherently intimate, offering the viewer a privileged glimpse into the private lives of their creators, like a scene glimpsed through a keyhole. Other types of painting, still lifes and genre portraits, in particular, arise from a kind of private interaction between the artist and his invention. They are unpretentious works in which modesty of scale corresponds perfectly to modesty of subject matter. In many cases such paintings were created not for exhibition or sale, but for the pure pleasure of their creation and were known only to the artist's closest associates, displayed or given as a mark of esteem. And then there is the intimacy of scrutiny, artist to object and viewer to object; in a way, the smallness of a work demands closer attention to every mark the artist made on the picture. That quality, in general, is absent from large-scale paintings since to take them in, viewers must regard them from a distance. The accessibility of smaller-scale works, both physical and psychological, is perhaps their greatest charm.

Edgar Degas, French, 1834–1917,
Self-Portrait with White Collar, c. 1857 (detail)

Throughout the 1850s, Degas focused much of his energy on intimate portraits, self-portraits, and depictions of family members. *René de Gas* is one such work and is among the artist's earliest known paintings. The subject is the artist's youngest brother, René, at the age of ten. Although only twenty-one when he painted his brother, Degas displays precocious skill in the delineation of his brother's rounded features and slightly self-conscious air. This sensitive rendering counterbalances the otherwise austere composition and restrained palette of the bust-length portrait. About two years later, Degas painted the *Self-Portrait with White Collar*, one of some fifteen painted between ages nineteen and twenty-five. This self-portrait is in the romantic tradition of introspection and self-inquiry; casting his face in shadow, Degas suggests a brooding, somber temperament. Already the work exhibits the probing character that will be a hallmark of Degas' mature portraits and scenes of contemporary life.

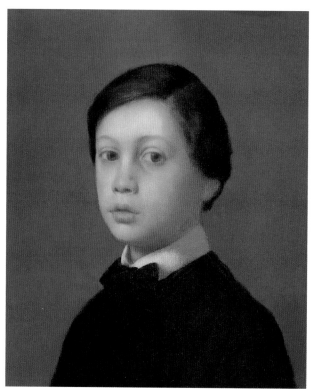

Edgar Degas
French, 1834–1917
René de Gas, 1855
oil on canvas, 38.6 x 32.1
(15 ³/₁₆ x 12 ⅝)
Collection of Mr. and Mrs.
Paul Mellon

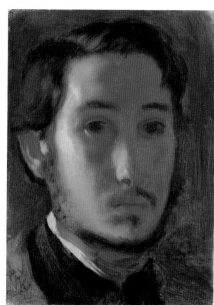

Self-Portrait with White Collar, c. 1857
oil on paper on canvas,
20.7 x 14.9 (8 ⅛ x 5 ⅞)
Collection of Mr. and Mrs.
Paul Mellon

Corot created portraits and figure studies throughout his career, works that include informal studies of peasants painted while he studied in Italy, portraits of relatives and close friends, and starting in the mid-1850s, genre figure studies. *Young Girl Reading* represents the type of figure study he developed. Paralleling the evocative "souvenir" landscapes, these were studio pieces depicting a single model, usually meditative in tone and accompanied by accessories in setting or costume that create a mood.

Such works form a distinct subgroup —naturalistically described, costumed models shown posing in Corot's studio. Juxtaposed with examples of the artist's work, they can allude to the classical idea of inspiration, the artist's muse. *Young Girl Reading* can sustain either interpretation: brisk, thick brushmarks render the model incisively, as if Corot worked hastily to capture that aspect of her appearance that inspired him. The late figure pieces were private studies that Corot seldom exhibited or sold.

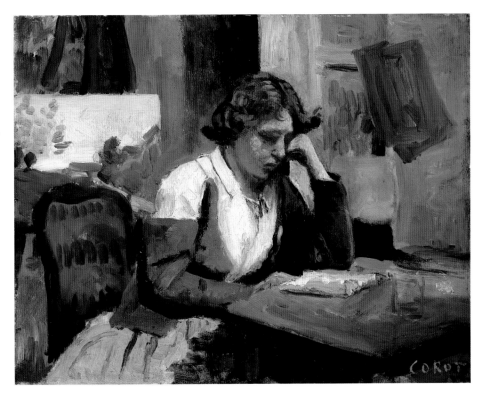

Jean-Baptiste-Camille Corot
French, 1796–1875
Young Girl Reading, c. 1868
oil on paperboard on wood,
32.5 x 41.3 (12^{13}/$_{16}$ x 16^{7}/$_{8}$)
Collection of Mr. and Mrs.
Paul Mellon

Monet spent the winter of 1868–1869 in Etretat with his mistress and future wife, Camille Doncieux, and their infant son, Jean, away from his family's disapproval of the relationship. Bosom friends occasionally visited, as commemorated by two paintings: *The Dinner* (Stiftung Sammlung E. G. Bührle, Zurich) and *Interior, after Dinner*. The settings are identical save the removal of remnants of the dinner. Camille, clad in a gray gown, is recognizable in both works, and Jean, seated in a high chair for the meal in the Zurich picture, is absent from the Washington painting. The other two diners in the Zurich painting have traditionally been identified as Alfred Sisley and his wife, although such an identification has been questioned. The tall, elegant Frédéric Bazille is easily recognized leaning against the mantel in the National Gallery painting, while the gentleman in the Zurich painting appears to be shorter than Bazille, his face broader, and his hair light brown rather than black. Bazille and Sisley were part of Monet's circle, so precise identification aside, this was a gathering of close friends, a casually intimate glimpse of the artist's private life.

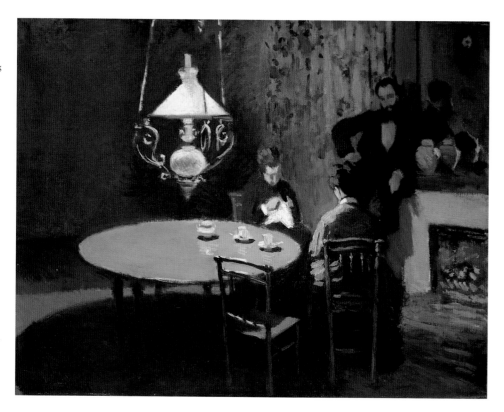

Claude Monet
French, 1840–1926
Interior, after Dinner,
1868/1869
oil on canvas, 50.5 x 65.7
(19⅞ x 25⅞)
Collection of Mr. and Mrs.
Paul Mellon

When Edma Morisot married and moved with her husband to the port city of Lorient, she left behind her sister Berthe, the first time the sisters had been separated. Berthe Morisot's health suffered until her parents sent her to visit. *The Artist's Sister at a Window*, painted then, is a genre scene rather than a portrait, showing the young woman turned away toward a balcony, situated to take advantage of the play of light across the white day dress. Before the marriage the sisters had enjoyed budding careers as artists, but by this time Edma was pregnant with her first child, a circumstance that ended any consideration of resuming painting. In a way, *The Artist's Sister at a Window* depicts Edma's choice as a kind of enforced idleness. Before leaving Paris, Morisot had posed for Edouard Manet's

The Balcony (Musée d'Orsay, Paris), and Edma's garb and placement echo Morisot's in the Manet painting. Edma's abstracted toying with her painted fan is the kind of keenly observed gesture that animates Morisot's work and reveals the sisters' intimacy.

Morisot submitted *The Artist's Sister at a Window* for exhibition at the Salon of 1870. Recounting a conversation with Manet, she wrote Edma that, "he told me that my Salon entry is assured and that I shouldn't torment myself, then he immediately added that of course I will be rejected." Manet's sardonic compliment notwithstanding, both of Morisot's entries (the other was the National Gallery's *The Mother and Sister of the Artist*) were accepted and shown at the Salon.

Berthe Morisot
French, 1841–1895
The Artist's Sister at a Window, 1869
oil on canvas, 54.8 x 46.3
(21⅝ x 18¼)
Ailsa Mellon Bruce
Collection

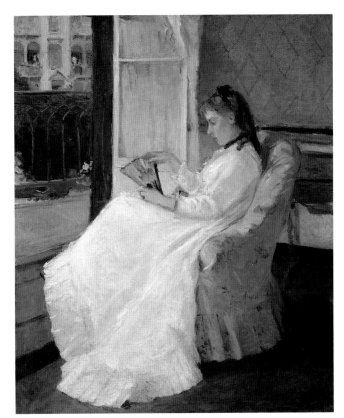

The name Tama inscribed on this painting identifies the animal securely as the pet of financier Henri Cernuschi (1821–1898). He and his friend, author and critic Théodore Duret (1838–1927), traveled for three years in East Asia; by their return in 1874, Cernuschi had become an avid collector of Asian art—his collection is the foundation of the Paris museum that bears his name. He also acquired a Japanese Chin dog, a breed then virtually unknown outside Japan, whom he named Tama, or jewel. Manet reportedly was averse to allowing dogs in his studio, lest they do any damage, but Duret, who earlier had accompanied Manet to Spain, apparently convinced him to paint this portrait, whose reddish-brown background situates the dog in Manet's studio.

A King Charles Spaniel is also related to that journey to Spain. It was painted soon after Manet's return to Paris in a manner reminiscent of paintings by Diego Velázquez (1599–1660) that he had seen at the Prado in Madrid. We know nothing more about this portrait, not the dog's name or owner nor who first owned the painting. The rarity of this subject for Manet suggests that *A King Charles Spaniel*, like Tama, is a result of intimacy. The alert bearing of both animals, their accessible, near-life-size presences, and Manet's sympathetic presentation of his pampered subjects seem to invite us to become acquainted with the dogs.

right:
Edouard Manet
French, 1832–1883
Tama, the Japanese Dog,
c. 1875
oil on canvas, 61 x 50
(24 x 19^{11}/₁₆)
Collection of Mr. and
Mrs. Paul Mellon

far right:
A King Charles Spaniel,
c. 1866
oil on linen, 46 x 38
(18⅛ x 15)
Ailsa Mellon Bruce
Collection

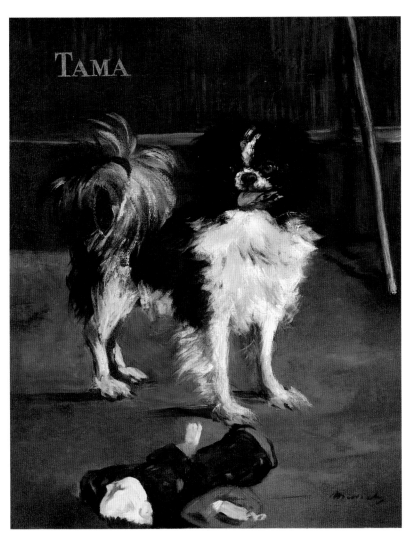

TAMA

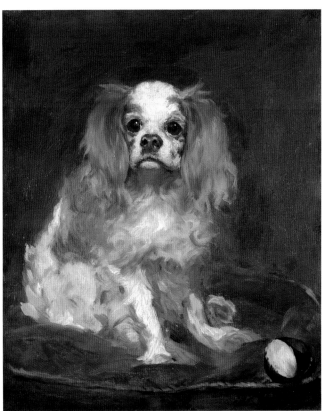

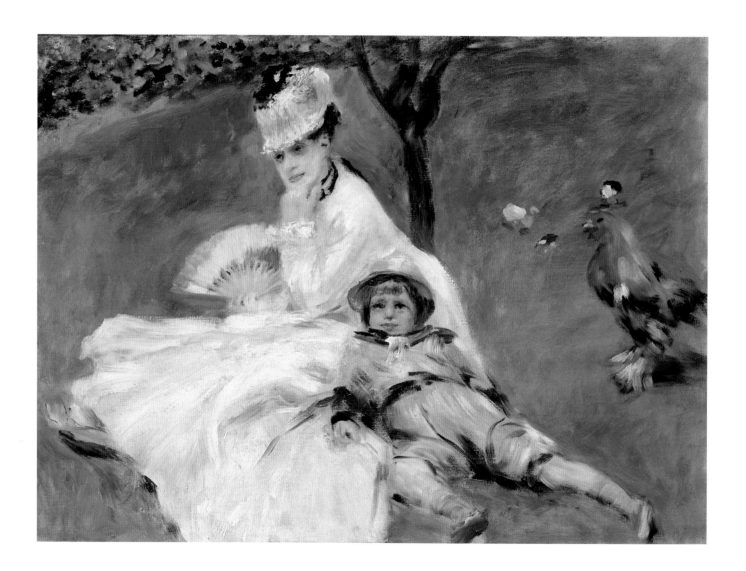

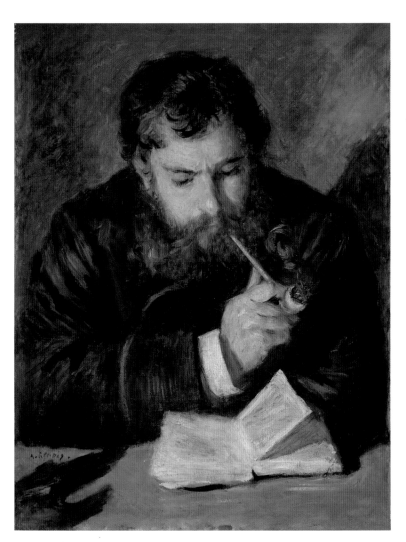

Madame Monet and Her Son and *Claude Monet* by Renoir bear witness to the personal friendship linking the two artists. Monet reminisced about a summer day in Argenteuil when Edouard Manet was visiting: "Enthralled by the color and light, [he] undertook an outdoor painting of figures under the trees. During the sitting, Renoir arrived. He, too, was caught up in the spirit of the moment. He asked me for palette, brush, and canvas, and there he was, painting away alongside Manet." (Marc Elder, *Chez Claude Monet à Giverny*, Paris, 1924, 70). Camille and Jean Monet are sprawled on the lawn in casual postures that demonstrate their familiarity with modeling and with the artists for whom they posed, a familiarity also suggested by the easy gaze Jean directs back at Renoir. Renoir painted several portraits of Monet, companion of his student days. *Claude Monet* is unusual, a postprandial picture of Monet relaxing with his pipe over a book. He is artificially lit and divorced from allusions to his profession—a side of Monet known only to his intimates.

opposite:
Auguste Renoir
French, 1841–1919
Madame Monet and Her Son, 1874
oil on canvas, 50.4 x 68
(19⅞ x 26¼)
Ailsa Mellon Bruce Collection

left:
Claude Monet, 1872
oil on canvas, 65 x 50
(25⁹/₁₆ x 19¹¹/₁₆)
Collection of Mr. and Mrs. Paul Mellon

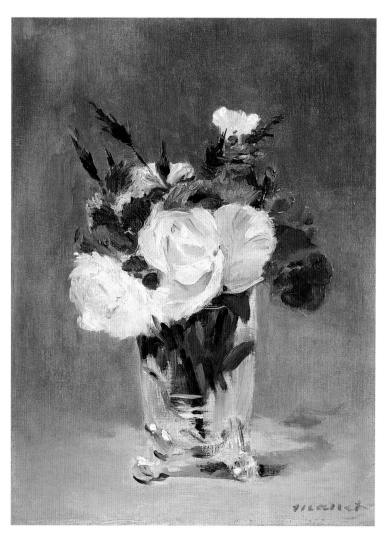

Manet was principally a figure painter, but still life was always an important element in his compositions, and it recurred as an independent subject throughout his oeuvre. During the mid-1860s Manet produced a number of large-scale still lifes, sumptuous images of flower arrangements and foodstuffs patterned on seventeenth-century Dutch paintings—elegant displays of his bold, supple technique. Still life was again a significant motif toward the end of Manet's life, from about 1880 until his death in early 1883. As the artist's health deteriorated, it became more difficult for him to work on a large scale. Pastels and small, easily managed oils figured increasingly in his production, culminating in a group of still lifes that includes *Flowers in a Crystal Vase*. This bouquet of roses, pinks, and pansies standing casually in a small container, probably painted in the summer of 1882, reportedly became a New Year's Day gift to a lady known only as Madame X. The vibrant bouquet is a charming souvenir of friendship from the end of Manet's life.

Edouard Manet
French, 1832–1883
Flowers in a Crystal Vase,
c. 1882
oil on canvas, 32.6 x 24.3
(12⅞ x 9⅝)
Ailsa Mellon Bruce
Collection

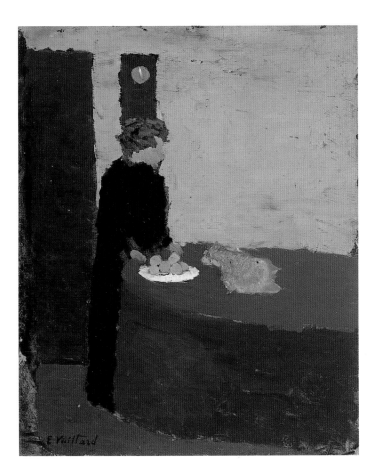

Vuillard, along with his friend and fellow Nabi Pierre Bonnard, were known as the "intimists" of the Nabi group, a title bestowed upon them in recognition of their predilection for paintings that were modest in scale and subject yet rich with nuance and mood. Vuillard, in particular, specialized in painting domestic interiors inspired by his own home and family life of which *Woman in Black* is a typical example. Composed of large, unmodulated areas of subdued color and simplified, almost abstract forms, the scene has a mysterious and timeless quality. Vuillard painted on an unprimed cardboard support, rather than canvas, an experiment with materials of the sort that interested him throughout his career. The untreated surface absorbed some of the oils in his paints, producing an unobtrusive, matte finish appropriate to the quiet image. Vuillard's domestic scene shows a woman standing by a table that is bare except for some orange-colored fruit piled on a plate and an animal, probably a cat. Although the figure may be the artist's sister Marie, who appears in many of his works, her features remain intentionally vague. This is not a portrait, but rather an evocation of a world that is both familiar and deeply private.

Edouard Vuillard
French, 1868–1940
Woman in Black, c. 1891
oil on cardboard,
26.8 x 21.9 (10½ x 8⅝)
Ailsa Mellon Bruce
Collection

The Yellow Curtain displays the decorative and abstract qualities that characterize Vuillard's Nabi paintings. Stretched across the composition is a yellow ocher curtain, its folds indicated by a rhythmic succession of browns. A figure, the artist's mother, pulls the curtain aside, offering the viewer a tantalizing glimpse of her dressing room, decorated in brightly patterned wallpaper and furnished with a dressing table and a small round mirror. Her gesture as well as her apparel and informal coiffure all indicate she has been captured just as she is about to dress for the day. The painting evokes an intensely private mood, a compelling and intimate glimpse of the life of the Vuillard family as the artist scrutinizes his mother while she faces herself in a mirror. Despite the potentially provocative subject, there is nothing prurient or deeply sensual about Vuillard's depiction. On the contrary, the image bespeaks a stateliness and modesty even as it hints at the hidden mysteries of a feminine world.

Edouard Vuillard
French, 1868–1940
The Yellow Curtain, c. 1893
oil on canvas, 34.7 x 38.7
(13⅝ x 15¼)
Ailsa Mellon Bruce Collection

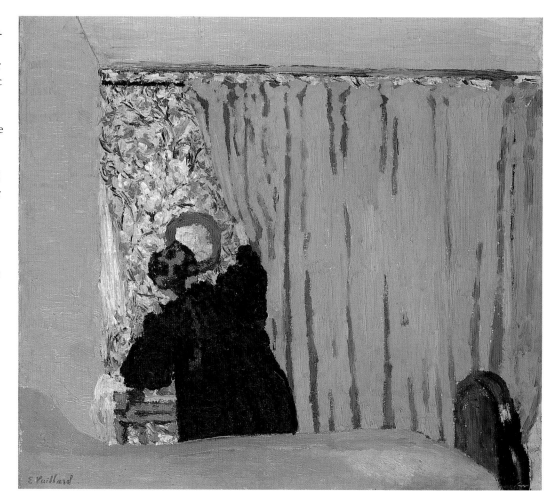

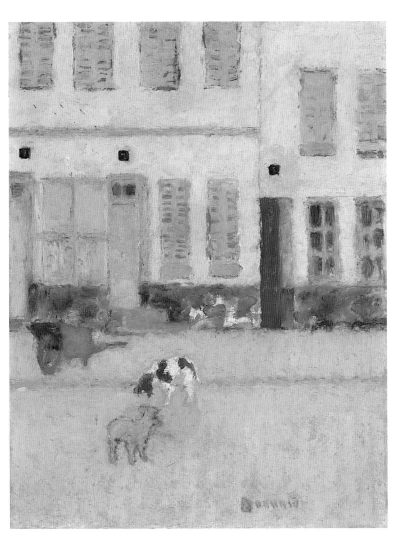

The unpretentious subject and the restrained presentation of *Two Dogs in a Deserted Street* are characteristic of Bonnard's intimist paintings. He selected a street lined with close-packed houses that he faced head-on, almost as if he were going to paint a portrait of the facades. Stripping incidental detail from the scene, Bonnard created a remarkably abstract composition. The juxtaposition of horizontal and vertical shapes lends the painting a rigorously geometric quality, but it is softened through the introduction of a nearly monochromatic palette of soft pink- and gray-tinged beiges. The austerity of the street itself is contrasted with a scene of gentle humor, one that he surely witnessed: the chance encounter between two stray dogs, who circle each other, wary and undecided. Their presence adds a touch of whimsy and animation to the otherwise quiet and curiously uninhabited cityscape.

Pierre Bonnard
French, 1867–1947
Two Dogs in a Deserted Street, c. 1894
oil on wood, 35.1 x 27 (13⅞ x 10⅝)
Ailsa Mellon Bruce Collection

Still Life combines elements common to many still lifes painted by Cézanne in later years. He repeatedly painted the objects here—fruit, ceramic pitcher, rounded white platter, glass, desk, and curtain—making small and large variations of placement and overall configuration. They were objects in his studio that he knew intimately, both from long familiarity and from the sustained process of looking that was integral to his art. Cézanne would customarily work on a canvas over a lengthy period; one man who posed in the 1890s complained of painfully long pauses between the placement of individual brushstrokes. When fruit he was painting rotted as he worked, Cézanne replaced it with wax fruit rather than proceed more quickly. Although the surface of *Still Life* bears evidence of the artist's working and reworking, the picture looks fresh, the colors rich and sonorous. The first owner of *Still Life* was Cézanne's old friend, Claude Monet, whose biographer Gustave Geffroy praised Cézanne's still lifes, saying that they "suggest the good smell of fruit."

Paul Cézanne
French, 1839–1906
Still Life, c. 1900
oil on canvas, 45.8 x 54.9
(18 x 21⅝)
Gift of the W. Averell
Harriman Foundation in
memory of Marie N.
Harriman (detail, opposite)

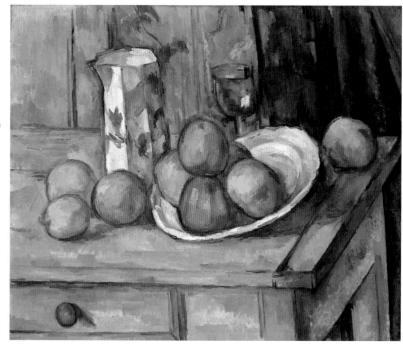

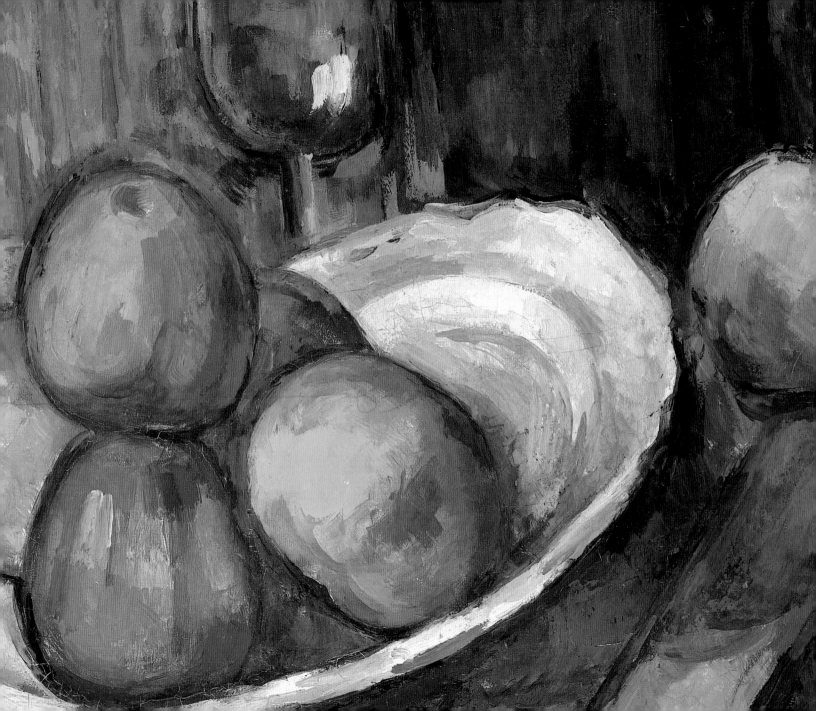

PAINTINGS AS COMMODITIES

The nineteenth century saw the emergence of a prosperous and socially mobile middle class for whom art, formerly available only to the wealthiest patrons—the monarchy, government institutions, the church, and the aristocracy—was accessible and affordable. From the dawn of the Middle Ages through the consolidation of the country under the Bourbon monarchs, the vast majority of people were impoverished peasants. However, during the Enlightenment and spurred by the movement of the court from Versailles to Paris, a new middle class of merchants and tradesmen arose to provide goods and services to the aristocracy. In the wake of the French Revolution this bourgeois middle class flourished, growing in numbers and wealth throughout the nineteenth century. And it was this newly prosperous middle class that became the new art clientele. The commercially driven art market prompted a number of changes within the art world. One of these was the rise of the profession of art dealer, an individual who served as intermediary between artists and patrons. Another was the scale of the works themselves. While a large-scale painting was appropriate for a palace or a church, it was ill suited to the more modest dwellings of the middle class. Consequently, smaller works became even more coveted.

Henri Fantin-Latour, French, 1836–1904,
Still Life, 1866 (detail)

The Bather is part of a group of some twenty small paintings of nudes that Millet produced in the late 1840s. These mildly titillating paintings generally depict young women bathing in secluded pastoral settings with peasant trappings added in to heighten their rustic quality. The broadly sketched improvisation shows a naked young shepherdess descending a bank to dangle her leg in a stream, leaving her clothing and staff piled safely behind her. The dark silhouette of a goat or cow signals her neglected herd in the field above. The model looks awkward and uncomfortable, an adolescent whose facial features are barely indicated. *The Bather* is a risqué composition created specifically for a commercial market as a means for the artist to support himself. Fearing that he would gain a reputation as a painter of licentious and frivolous nudes, however, he soon abandoned such subject matter to focus his attention exclusively on the scenes of rural life for which he would become best known.

Jean-François Millet
French, 1814–1875
The Bather, 1846/1848
oil on wood, 18.5 x 24.1
(7½ x 9½)
Gift of R. Horace Gallatin

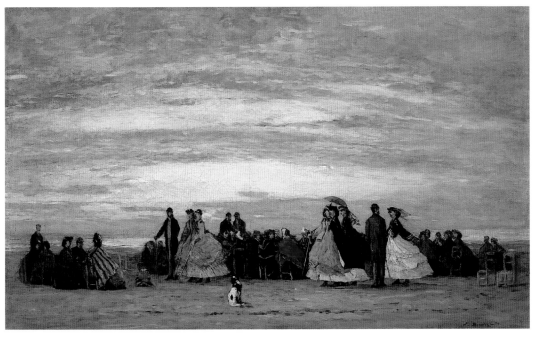

Eugène Boudin
French, 1824–1898
The Beach at Villerville,
1864
oil on canvas, 45.7 x 76.3
(18 x 30)
Chester Dale Collection

Boudin gained both critical and commercial success in the 1860s with paintings depicting the glittering society that congregated at the fashionable resorts along the Normandy coast. *The Beach at Villerville* is a typical example of such works. His brushwork meticulously describes a throng of elegant tourists as they stroll along a beach at twilight. Even the stray hound in the center of the painting seems well groomed and neat. The painting's dimensions along with its rather finished surface suggest that this was a studio work created specifically for the commercial market, a market that coveted such images of the wealthy and fashionable at play. Nevertheless, despite its somewhat conventional subject and oft-repeated composition, Boudin's dedication to the practice of open-air painting is also apparent in the fluid rendering of the sky and the limpid, light-filled palette. Through keen observation and deft handling, Boudin takes a somewhat formulaic subject and transforms it into a surprisingly inventive and lyrical work.

Fantin-Latour's *Still Life* is a luxurious display piece painted in a relatively conservative, academic style. His rendering of the textures of individual components of the still life enlivens the surface in a manner that recalls Jean-Siméon Chardin, whose work was rediscovered around this time. A compendium of objects of various textures that take the light differently is arrayed around the tabletop; Fantin plays the translucence of an opened orange off against the thick, not-quite-matte rind of an unpeeled orange, a delicate porcelain cup and saucer, a glossy japanned tray, a worn blue book cover, and the gleaming wood of the table supporting them.

Fantin began to exhibit his floral still-life paintings in England in 1862 where he found a very receptive market. Bolstered by his growing success abroad, he exhibited at the Salon of 1866 in the hopes of finding patronage for such works in France as well. Even at that early stage of his career, however, Fantin expressed ambivalence toward this aspect of art in a 15 May 1862 letter to Edwin Edwards, his London dealer: "I have never had so many ideas on art in my head and am forced to paint flowers! While I am painting them, I imagine Michelangelo before peonies and roses. It cannot go on like this."

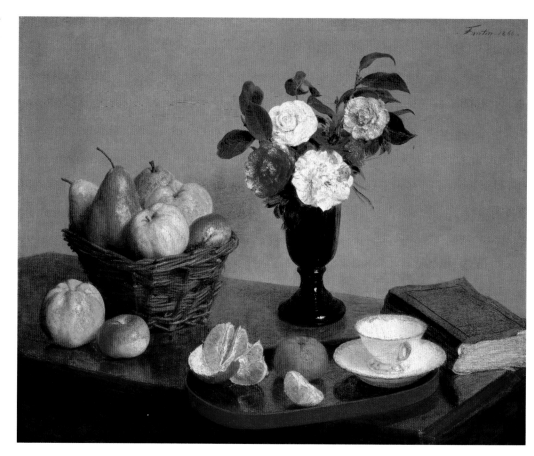

Henri Fantin-Latour
French, 1836–1904
Still Life, 1866
oil on canvas, 62 x 74.8
(24⅜ x 29½)
Chester Dale Collection

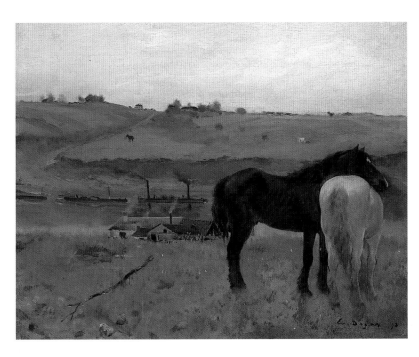

Like dancers and laundresses, horses were a recurrent motif in Degas' work. Better known for depictions of thoroughbreds, Degas has taken a pair of draft animals as the subject of *Horses in a Meadow*. On gently rolling hills in Normandy at daybreak in spring, one horse has laid his head across the other's back, a gesture of familiarity and trust between the two. Work is stirring on the river below, and the old work horses, displaced from jobs hauling the barges, still respond to the activity. In its organization and overall silvery tonality, the painting resembles naturalist landscapes by Corot, as well as landscapes painted in 1871 and 1872 by Monet, Morisot, Pissarro, Renoir, and Sisley.

Degas was notoriously reluctant to part with his work, even to the extent of deferring for several years the delivery of a painting he already had sold. *Horses in a Meadow* was different. Shortly after it was painted it was sold (and delivered) to dealer Durand-Ruel, who in turn sold it to Degas' friend, painter James Tissot.

Edgar Degas
French, 1834–1917
Horses in a Meadow, 1871
oil on canvas, 31.75 x 40
(12½ x 15¾)
Chester Dale Fund

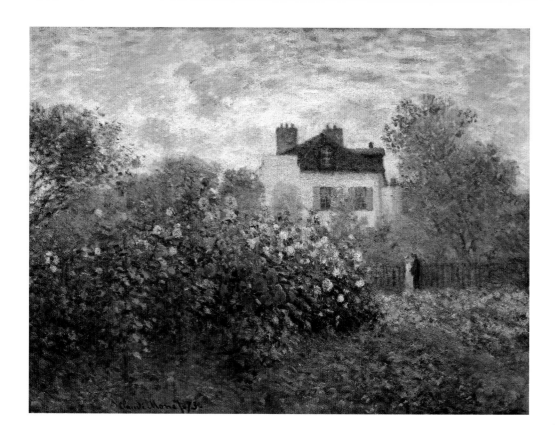

Claude Monet

Monet's most famous garden was at Giverny, the first home he owned. He began to cultivate flower gardens much earlier, though, at the house he rented from 1871 to 1874 in Argenteuil. *The Artist's Garden in Argenteuil* is one of his first paintings of his gardens, and in it he described the burgeoning bed of dahlias with a gardener's knowledge-able passion. Monet modified the appearance of the house and grounds to create a larger garden remote from neighbors in the crowded suburb, a more visually, aesthetically and personally satisfying image.

Renoir's painting, *Madame Monet and Her Son* (page 46), shows a secluded corner of the same Argenteuil garden, a virtuoso souvenir of the artists' friendship, one that Monet kept in his collection. By contrast, this view by Monet was a commercial product, invented for the market and sold in 1873 to dealer Durand-Ruel, a sale necessitated by Monet's desire to maintain his family's prosperous situation.

Claude Monet
French, 1840–1926
The Artist's Garden in Argenteuil (A Corner of the Garden with Dahlias), 1873
oil on canvas, 61 x 82.5 (24⅛ x 32½)
Gift of Janice H. Levin, in Honor of the 50th Anniversary of the National Gallery of Art

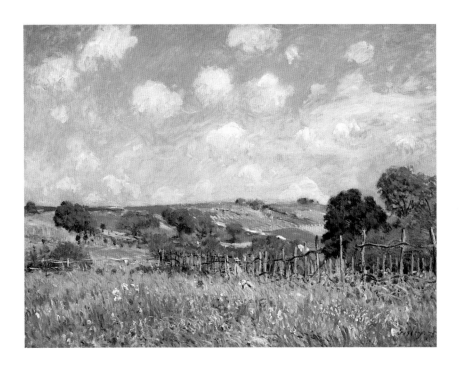

Alfred Sisley

Unlike his impressionist colleagues, Sisley concentrated almost exclusively on landscape painting throughout his career; his style also remained consistently impressionist, again, unlike that of his comrades. His paintings, particularly those of the mid-1870s, are lyrical and unembellished renditions of the scenery of France. *Meadow* is a work of surprising beauty, showing peaceful, fenced pastures alive with wild flowers on a warm, sunny day. Sisley's colleagues admired his work; Pissarro described him as the perfect impressionist painter.

The composition and content of *Meadow* are relatively uncomplicated and unchallenging and the painting's size is moderate, more suited to private enjoyment than public display, characteristics that might have made *Meadow* a marketable commodity. Indeed *Meadow* has not been identified as publicly exhibited by Sisley. We do not know when the picture left Sisley's studio, its earliest appearance being in the collection of the Count Armand Doria (1824–1896), an important early patron of the impressionists. In his late years, Sisley said his bitterest regret was that he never achieved commercial success or public acceptance, in contrast to such prosperous friends as Monet, Renoir, and Pissarro. Toward the end of his life he and his family were impoverished.

Alfred Sisley
French, 1839–1899
Meadow, 1875
oil on canvas, 54.9 x 73
(21⅝ x 28¾)
Ailsa Mellon Bruce
Collection

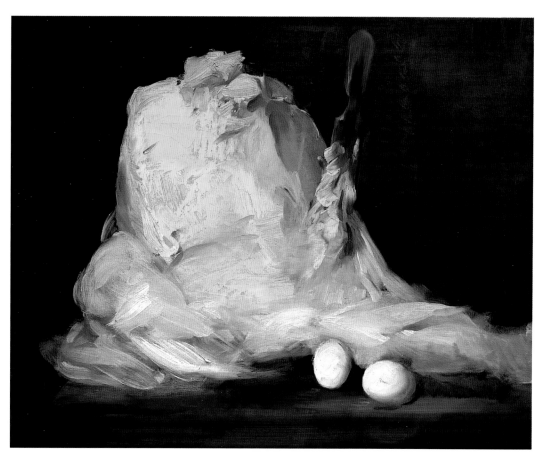

A revival of interest in the eighteenth-century French master Jean Siméon Chardin created a vogue for still-life paintings in the mid-nineteenth century, and his influence marks the work of the realist painter Antoine Vollon. Vollon specialized in still-life paintings, some being rich displays and others, unpretentious kitchen still lifes. *Mound of Butter* is one of the latter, an unadorned depiction of a large lump of butter as it might appear in a shopkeeper's display, wooden spatula stuck to the side and enrobed in gauzy cheesecloth, here painted with two small eggs nearby to indicate the relative size of the commodity. Vollon depicted the butter with dense pigments that emulate the appearance of the butter, shaping the paint with a palette knife as vigorously as the spatula shaped the butter.

Antoine Vollon
French, 1833–1900
Mound of Butter, 1875/1885
oil on canvas, 50.16 x 60.96
(19¼ x 24)
Chester Dale Fund

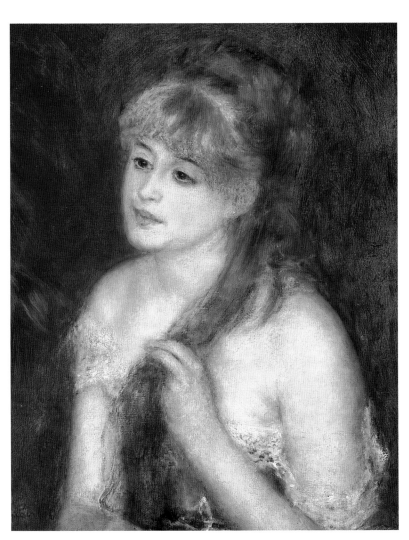

The harsh critical reception of the impressionists' first group exhibition in 1874 and disastrous results of an auction the artists organized in 1875 placed Renoir in a precarious financial situation. At that time, perhaps as a remedy, he began to paint genre portraits, anecdotal depictions of children and young women. Such a work is *Young Woman Braiding Her Hair*. The model has traditionally been identified as Mademoiselle Muller, of whom nothing further is known; and while most women who posed for the genre portraits are named individuals who modeled for Renoir on multiple occasions, this is his only depiction of this particular woman.

The model's flowing red tresses gave the painting its first title, *La Chevelure* (in English, head of hair). Scantily clad in a white undergarment, the woman's soft skin glows against a plain purple background. Such figure paintings, less daring stylistically than an experimental work like *Madame Monet and Her Son* (page 46), could be more commercially viable. *Young Woman Braiding Her Hair* is a titillating showcase of the grace and charm of Renoir's work.

Auguste Renoir
French, 1841–1919
Young Woman Braiding Her Hair, 1876
oil on canvas, 55.5 x 46 (21¼ x 18⅛)
Ailsa Mellon Bruce Collection

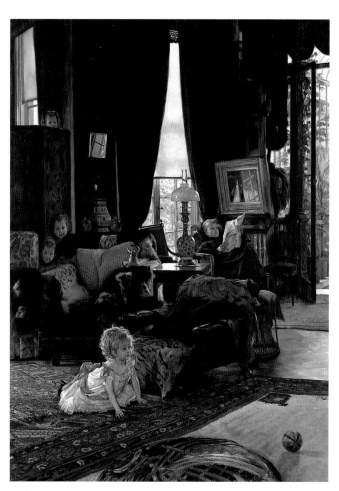

Hide and Seek displays the opulent clutter of a modern Victorian sitting room, Tissot's own studio. The woman reading a newspaper is the artist's companion, Kathleen Newton, and the playful children are her nieces and daughter. Every inch of wall space in the studio is covered, a showcase of works of art and curiosities that could inspire visiting patrons to acquire something for their own walls. Tissot's academic training is evident in his suavely polished paint handling, a technique he used to advantage in scenes of contemporary life like *Hide and Seek*.

When Degas and his impressionist colleagues were organizing the first impressionist exhibition, he wrote to exhort Tissot, a friend from his student days, to join the enterprise. Degas wrote, "You positively must exhibit at the Boulevard [with the impressionists]. So forget the money side for a moment. Exhibit. Be of your country and with your friends." In other words, Degas wanted to persuade Tissot that allegiance to French art outweighed the danger of offending patrons Tissot had cultivated in London. Tissot declined.

left:
James Jacques Joseph Tissot
French, 1836–1902
Hide and Seek, c. 1877
oil on wood, 73.4 x 53.9
(28⅞ x 21¼)
Chester Dale Fund

right:
Mary Cassatt
American, 1844–1926
Children Playing on the Beach, 1884
oil on canvas, 97.4 x 74.2
(38⅛ x 29¼)
Ailsa Mellon Bruce
Collection

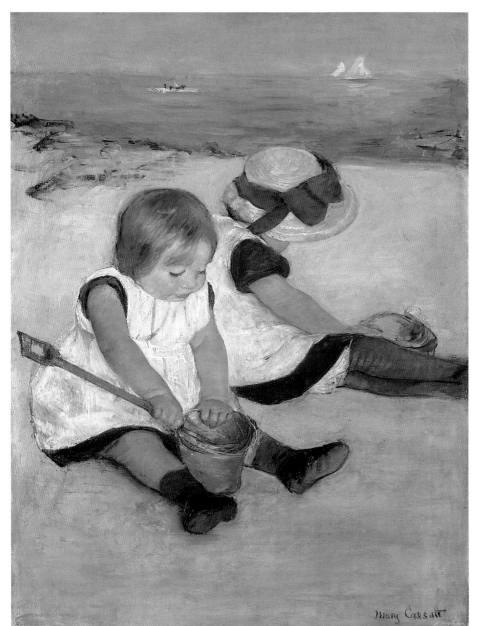

Children Playing on the Beach is ostensibly a naturally observed depiction of a casual scene, but the painting's simplicity is deceptive. Influenced by Japanese woodcuts and by Degas, her impressionist mentor, Cassatt selected a bird's-eye view, raising the horizon and placing the children against an unbroken sandy foreground. The original design has been reworked extensively—adjustments are clearly visible in the placement and contour of the children's limbs—effectively eliminating incidental detail to emphasize the vulnerable charm and natural innocence of the two girls. Cassatt began work on the canvas in 1884, when she accompanied her convalescing mother to Spain, but she did not exhibit it until the 1886 impressionist group show, suggesting that she continued to modify the canvas after her return to Paris. Critics in 1886 lauded the "naturalism and truth" of the painting, and one wrote that "these are real babies who play in the sand convincingly." Cassatt made a reputation as a masterful painter of women and children with works like *Children Playing on the Beach* and established a career as a successful professional artist.

In its luminous palette and free brush-
work, *Place du Carrousel, Paris* resembles
Pissarro's early impressionist *Orchard in
Bloom, Louveciennes* (page 23) more close-
ly than it does his more recent work. The
artist had gone back to his impressionist
roots following a period of experimenta-
tion with neoimpressionism. As well as
being a return to his previous style,
Pissarro is also revisiting here a subject
associated with the early phase of impres-
sionism; Manet, Monet, Renoir, and
Sisley painted Parisian cityscapes in the
1860s and early 1870s, a subject Pissarro
had avoided but which he undertook in
the hope of achieving the commercial
success that had long eluded him.
Chronic eye ailments precluded working
in the open, so Pissarro followed the pro-
cedure Monet established for his series
of paintings of Rouen Cathedral by rent-
ing a Paris apartment with views of a
panorama encompassing the Louvre, the
Arc de Triomphe in the center of the
Place du Carrousel, and the parterres of
the Tuileries Garden. As Monet had done
in the cathedral series, Pissarro painted
the landmarks under differing weather
conditions and times of day. Twenty-eight
paintings from Pissarro's series survive,
of which *Place du Carrousel, Paris* is one
of just thirteen he included in his one-
man show and sale in 1901.

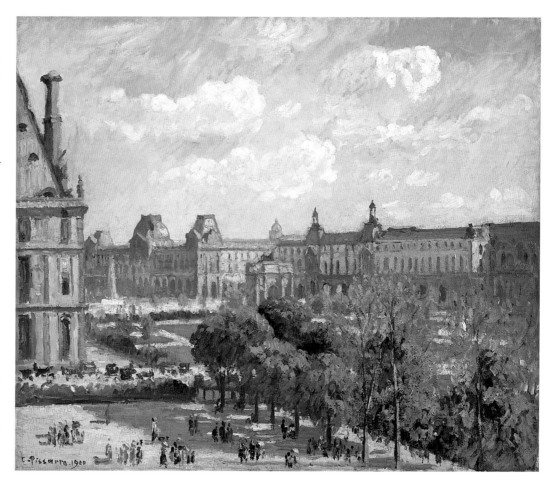

left:
Camille Pissarro
French, 1830–1903
Place du Carrousel,
Paris, 1900
oil on canvas, 54.9 x 65.4
(21⅝ x 25¾)
Ailsa Mellon Bruce
Collection

Redon was an exact contemporary of
Monet and Morisot and a year older
than Renoir, yet his work deliberately
has little in common with impression-
ism. For Redon, art was a synthesis of
the visual and visionary, and he pre-
ferred to evoke rather than describe.
From the late 1860s Redon was prima-
rily a graphic artist whose macabre and
mysterious charcoals allied him with
writers and artists of the symbolist
movement. In about 1890, color
became an important element of the
artist's work and floral motifs, which
he included in portraits and allegories
as well as still lifes, dominated Redon's
production. In 1913 Redon wrote of
flowers as "fragile perfumed beings,
adorable prodigals of light," a charac-
terization suited to the bouquet of
ordinary summer blossoms, probably
grown by Redon in his garden, depicted
in *Flowers in a Vase.*

Odilon Redon
French, 1840–1916
Flowers in a Vase, c. 1910
oil on canvas, 55.9 x 39.4
(22 x 15½)
Ailsa Mellon Bruce
Collection

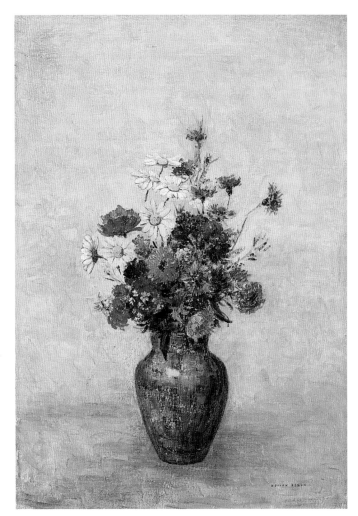

EXPERIMENTS IN PAINTING

Working on a small scale can inspire an artist to experiment. In fact, one might even posit that the making of small-scale paintings actively encouraged the process of creation. For many artists, small works were studies, where the process of trial and error took place, and the results could be both unexpected and quite felicitous. Bold techniques, unusual color combinations, odd juxtapositions, and exaggerated flourishes can occur accidentally or deliberately when working on a small scale; if ineffective, the artist has not wasted much time or money in the endeavor, and success is its own reward. A smaller format was also conducive to the use of less conventional supports, some of which were impractical on a large scale. By exploring the unique qualities of these alternative supports—the relatively smooth surface of a wood panel or the absorbent nature of cardboard—artists learned that they could achieve unusual and unexpected effects. While some of these successful experiments would eventually be carried out in larger works, in others the small-scale painting became the ultimate work of art, reinforcing the exceptional potential of the small format.

Paul Cézanne, French, 1839–1906,
The Battle of Love, c. 1880 (detail)

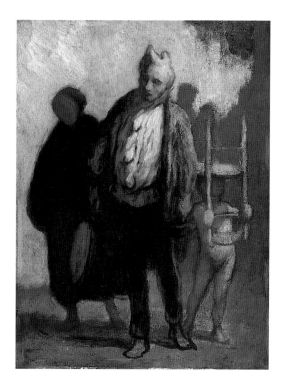

Daumier began his career as a printmaker whose political cartoons and humorous caricatures satirizing contemporary life were regularly published in the Parisian journals. As a painter, however, he was self-taught. He adapted the graphic methods of which he was a master to the very different demands of oils. The result is an unpolished and uncompromising style that was uniquely his own. The strong silhouettes, light on dark and dark on light, and blunt, flattened shapes that define the figures in *Wandering Saltimbanques* and the simplified space they occupy are stylistic elements that originated in his printmaking. The generalized features of the itinerant performers, an effect of his crude paint handling, endow them with broader meaning. Daumier sympathetically revealed the poverty and isolation of the offstage lives of the street musicians and acrobats.

Daumier seldom exhibited his paintings but when he became impoverished in the 1870s, he worked with dealer Paul Durand-Ruel to organize a one-man exhibition and sale. *Wandering Saltimbanques*, painted some thirty years earlier and still in the artist's personal collection, was included in that important showing.

Honoré Daumier
French, 1808–1879
Wandering Saltimbanques,
1847/1850
oil on wood, 32.6 x 24.8
(12⅞ x 9¾)
Chester Dale Collection

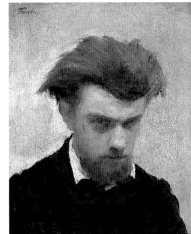

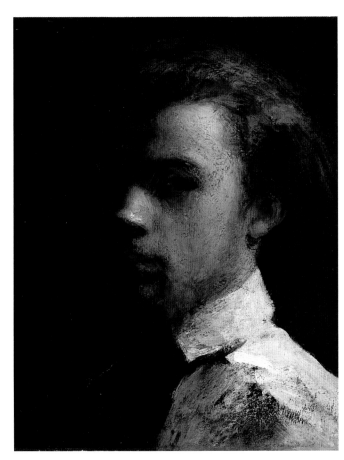

above:
Henri Fantin-Latour
French, 1836–1904
Self-Portrait, 1861
oil on canvas, 25.1 x 21.4
(9⅞ x 8⁷⁄₁₆)
Collection of Mr. and Mrs.
Paul Mellon

left:
Self-Portrait, 1858
oil on canvas, 40.7 x 32.7
(16 x 12⅞)
Chester Dale Collection

Between 1853 and 1861, Fantin-Latour created some thirty self-portraits, works that evince his gradual mastery of portraiture. The result of intense and often uncompromising self-scrutiny, self-portraits tend to be extremely private works. They are also among the most experimental; such works allow the artist to try out unfamiliar techniques and explore unusual effects of pose, figure placement and scale, costume, and lighting. Painted three years apart, these two self-portraits reveal different aspects of the artist's character. The *Self-Portrait* of 1858 shows a calm, confident young man who gazes at the viewer with a measured, sidelong gaze, his placid expression at odds with his bravura brushwork. Thick, dragged paints shape his face, which dramatic chiaroscuro has turned into a pattern of darks and lights. By contrast, the 1861 *Self-Portrait* is all fire and intensity. It is thinly painted, as if captured in the throes of artistic inspiration, rather than methodical execution. With the lowered head, unruly hair, and the fierce stare from under beetling brows, Fantin portrays himself as the very embodiment of the romantic genius. It is as passionate as the other self-portrait is deliberate.

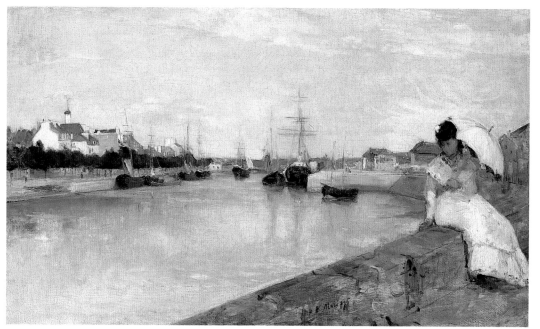

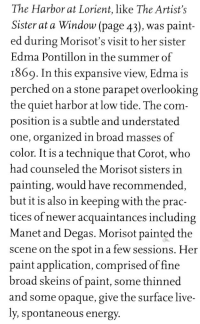

Berthe Morisot
French, 1841–1895
The Harbor at Lorient, 1869
oil on canvas, 43.5 x 73
(17⅛ x 28¾)
Ailsa Mellon Bruce
Collection

The Harbor at Lorient, like *The Artist's Sister at a Window* (page 43), was painted during Morisot's visit to her sister Edma Pontillon in the summer of 1869. In this expansive view, Edma is perched on a stone parapet overlooking the quiet harbor at low tide. The composition is a subtle and understated one, organized in broad masses of color. It is a technique that Corot, who had counseled the Morisot sisters in painting, would have recommended, but it is also in keeping with the practices of newer acquaintances including Manet and Degas. Morisot painted the scene on the spot in a few sessions. Her paint application, comprised of fine broad skeins of paint, some thinned and some opaque, give the surface lively, spontaneous energy.

When Morisot returned to Paris at summer's end, she was visited by Manet, who so admired *The Harbor at Lorient* that she presented it to him on the spot. In 1874, when Manet refused to participate in the first impressionist exhibition, Morisot was able to persuade him to let her borrow *The Harbor at Lorient* for the show.

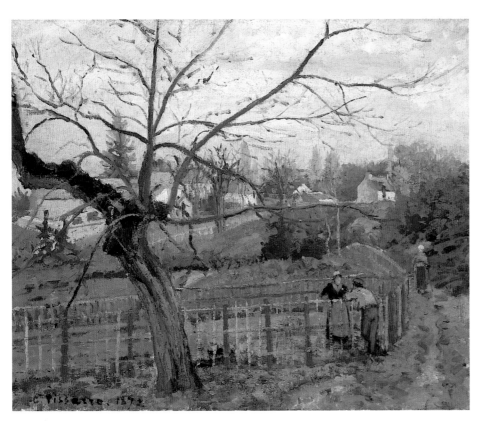

Camille Pissarro
French, 1830–1903
The Fence, 1872
oil on canvas, 37.8 x 45.7
(14⅞ x 18)
Collection of Mr. and Mrs.
Paul Mellon

In *The Fence* Pissarro depicted a rustic fenced garden plot and dirt pathway on the outskirts of a small village, probably either Louveciennes, where the family resided until spring 1872, or Pontoise, to which they moved. Pissarro's well-ordered composition and the tranquil rural setting inhabited by a few peasants recall the more traditional work of his mentor, Corot. Pissarro's luminous palette of greens, reds, blues, and earthen tones, and the spontaneous freedom of his brushwork are characteristics of the impressionist style he had created with Monet, Renoir, and Sisley.

The small size of his canvas encouraged Pissarro's daring brushwork, squiggled marks perhaps standing for thicker grasses on the pathway. The extraordinary arching, half-dead tree trunk was formed by repeated passes of the palette knife. New growth bursts forth above, rendered by a tangled web of blunt brushstrokes.

Paul Cézanne

The Battle of Love is a violent bacchanal inspired in part by ancient literature and in part by pastoral and mythological paintings. Cézanne's reported ambivalence toward women also affected his interpretation of classical themes. Cézanne repeated the motif in a contemporaneous watercolor and a second version in oils. The posture of the central pair, wreathed in golden hair, is derived from Cézanne's 1867

painting *The Rape* (King's College, Cambridge), in which the aggressor is male and the victim female.

The artist reworked the motif further in pictures of female bathers that culminate in three monumental compositions painted between 1900 and 1906, the *Grand Bathers* (National Gallery, London, Philadelphia Museum of Art, and The Barnes Foundation, Merion,

Pennsylvania). Cézanne derived the other struggling figures in *The Battle of Love* from early work and adapted them in the late paintings of bathers. The setting, a stagelike grassy area framed by trees with a broad body of water in the background, is used in the monumental *Bathers*. A transitional work, *The Battle of Love* is a provocative, elusive, and compelling composition from the midpoint of Cézanne's career.

Paul Cézanne
French, 1839–1906
The Battle of Love, c. 1880
oil on canvas, 37.8 x 46.2
(14⅞ x 18¼)
Gift of the W. Averell
Harriman Foundation in
memory of Marie N.
Harriman

Pierre Bonnard
French, 1867–1947
*Paris, Rue de Parme on
Bastille Day*, 1890
oil on canvas, 79.2 x 40.3
(31¹/₁₆ x 15⅞)
Collection of Mr. and Mrs.
Paul Mellon

Pierre Bonnard

Paris, Rue de Parme on Bastille Day is one of Bonnard's first depictions of the city's streets and residents and is the largest of the few paintings datable to this early phase of Bonnard's long career. Bonnard was still a student when he painted this view from his grandmother's apartment in the Batignolles quarter. The unusual vertical format, the oblique composition, and telescoping perspective signify Bonnard's admiration for Japanese prints and reflect the orderly calm of the bourgeois neighborhood on the national holiday.

Bonnard's technique is intuitively experimental. He penciled his composition on the canvas before he began to paint. He could then emphasize or further define the composition in pencil, as can be seen in the profiles and footwear of the figures at lower right. A fine grid structure underlies the street, separated from the sidewalk by a narrow black line, producing a nuanced yet arbitrarily flat and decorative appearance. Bold red areas in costumes and flags accent the otherwise subdued color harmonies in the residential neighborhood. A journal and unidentifiable timepiece (a clock, or perhaps a pocket watch) inserted at the far right, cut by the painting's edge and visually unrelated to the rest of the picture, evidence the playfulness of the still-youthful artist.

Matisse's style underwent a dramatic transformation around 1905. In the summer of 1904, he had traveled south where he encountered Paul Signac and Henri Cross, both adherents of neo-impressionism. Matisse dabbled briefly in this style though he adapted it to suit his own needs. Each touch of color was treated as a discrete element of the painting; the brushwork grew more exaggerated and the compositions broader and more simplified. In *Still Life*, Matisse is moving ever closer toward abstraction as subject is subordinated in favor of technique. Conventional modeling has been virtually abandoned, and forms are defined not through light and shadow but through color and brushstroke. The forms themselves remain intentionally ambiguous; a small green ceramic container at right and summarily indicated bottle near the center are the only readily identifiable elements within the composition. In this quickly brushed study, the artist's admiration for Van Gogh is evident in the richly impasted brushwork. Matisse merged felicitous accident with deliberate experiment to create a concentrated arrangement that scintillates with jewel-like brilliance.

Open Window, Collioure is a work of astonishing beauty and an icon of fauve painting. In 1905 Matisse summered with André Derain in Collioure, a town in the south of France, and the two made significant advancements in their art-making. Derain wrote fellow fauve Maurice de Vlaminck to report some of the innovations: "A new conception of light consisting in this: the negation of shadows. Light, here, is very strong, shadows very bright. Every shadow is a whole world of clarity and luminosity which contrasts with sunlight…" and "…eradicate everything involved with the division of tones…. It's logical enough in a luminous, harmonious picture. But it injures things that owe their expression to deliberate disharmonies" (Judi Freeman, *The Fauve Landscape*, New York, 1990, 15–16). *Open Window, Collioure* embodies the ideas Derain tried to convey. Pairs of brilliant near-complementary colors describe a succession from cool interior to glazed window embrasure, flower-decked balcony, and near incandescent harbor beyond.

Shortly after Matisse's return to Paris, he selected ten recent paintings,

among them *Open Window*, for display at the Salon d'Automne. His work was shown with paintings by other artists in his group, Derain, Charles Camoin, Henri Manguin, Albert Marquet, and Vlaminck. Journalist Louis Vauxcelles sarcastically dubbed the artists *fauves* (wild beasts) and—as with the impressionists in 1874—the word became the term by which they are known.

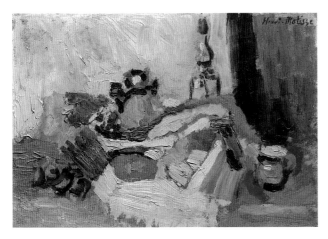

above:
Henri Matisse
French, 1869–1954
Still Life, c. 1905
oil on cardboard on wood,
17 x 24.8 (6¾ x 9¾)
Ailsa Mellon Bruce
Collection

right:
Open Window, Collioure, 1905
oil on canvas, 55.25 x 46.04
(21¾ x 18⅛)
Collection of Mr. and Mrs.
John Hay Whitney

Raoul Duly 1906.

The fauve room at the Salon d'Automne exhibition in 1905 was a revelation to Dufy. He later commented that when he saw one of Matisse's paintings, "I understood the new raison d'être of painting, and impressionist realism lost its charm for me as I beheld this miracle of creative imagination at play, in color and drawing" (Alfred Werner, *Raoul Dufy*, 1987, 20). Dufy joined the group, gradually over the next several months adopting their ideas about art and their style of painting. The eleven pictures of Bastille Day in Le Havre that he painted in 1906 showcase his mastery of fauvism.

In *July 14 in Le Havre*, Dufy sketched in the essential features of the composition with apparent ease, then added transparent washes of color with little concern for enclosing them in drawn contours. With sparkling color and a remarkably deft and varied touch, Dufy captured the brilliant atmosphere of the celebration of the national holiday in his native Le Havre. Its exuberance is all the more striking when contrasted with Bonnard's painting depicting the celebration of the same holiday in Paris a few years earlier (page 75).

Raoul Dufy
French, 1877–1953
July 14 in Le Havre, 1906
oil on canvas, 54.6 x 37.8
(21½ x 14⅞)
Collection of Mr. and Mrs. Paul Mellon

further reading

This book is only an introduction to the subject. Literature devoted to nineteenth-century French paintings is ever-expanding, and it would be impossible in this small volume to cite all the scholarly publications that have appeared even just since the inauguration of the National Gallery's East Building and opening of the *Small French Paintings* exhibition. A few texts, however, are basic to the field: *19th-Century Art* by Robert Rosenblum and H. W. Janson (Englewood Cliffs, N.J., 1984); John Rewald's *The History of Impressionism* (4th rev. ed., New York, 1973) and *Post-Impressionism: From Van Gogh to Gauguin* (3d ed., New York, 1982); and Robert L. Herbert's *Impressionism: Art, Leisure, and Parisian Society* (New Haven and London, 1988). One excellent recent book addresses technical issues not usually covered by art-historical studies, *The Art of Impressionism: Painting Technique and the Making of Modernity* by Anthea Callen (New Haven and London, 2000). The National Gallery of Art internet site (www.nga.gov) makes available extensive information about the works included in this book and other works in the collection, including provenance, exhibition history, and bibliographies.

artists and titles

First published in 2004 by GILES
An imprint of D Giles Limited
57 Abingdon Road
London W8 6AN, UK
www.gilesltd.com

ISBN: 1 904832 03 2

Library of Congress Cataloging-in-Publication Data

Coman, Florence E.
 Impressionism, an intimate view : small French paintings in the National Gallery of Art / Florence E. Coman ; foreword by Philip Conisbee.
 p. cm.
 Includes index.
 ISBN 1-904832-03-2 (hardcover : alk. paper)
 1. Small painting, French--19th century--Catalogs. 2. Impressionism (Art)--France--Catalogs. 3. Painting--Washington (D.C.)--Catalogs. 4. National Gallery of Art (U.S.)--Catalogs. I. National Gallery of Art (U.S.) II. Title.
ND547.C58 2004
759.4'09'034074753--dc22
2004009334

Edited by Karen Sagstetter and Sarah Kane
Designed by Anikst Design, London
Produced by D Giles Limited
Printed and bound in Hong Kong

All measurements are in centimeters and inches

10 9 8 7 6 5 4 3 2 1

Photographic Ackowledgments

All photographs have been supplied courtesy of the National Gallery of Art, Washington. In addition, GILES would like to acknowledge the following holders of copyright:

© ADAGP, Paris and DACS, London 2004: pp. 49, 50, 51, 75 and 78
© Succession H Matisse/DACS 2004: p. 77

Note: While the majority of the works discussed in this book are on public view most of the time, the display in the National Gallery is modified on occasion.

Front cover: Edgar Degas, *Dancers Backstage*, 1876/1883 (detail)
National Gallery of Art, Washington, Ailsa Mellon Bruce Collection

Back cover: Claude Monet, *The Artist's Garden in Argenteuil (A Corner of the Garden with Dahlias)*, 1873 (detail)
National Gallery of Art, Washington, Gift of Janice H. Levin, in Honor of the 50th Anniversary of the National Gallery of Art

Frontispiece: Camille Pissarro, *Orchard in Bloom, Louveciennes*, 1872 (detail)
National Gallery of Art, Washington, Ailsa Mellon Bruce Collection